Seven roles of women:
Impact of education, migration and
employment on Ghanaian mothers

Women, Work and Development, 13

Seven roles of women: Impact of education, migration and employment on Ghanaian mothers

Christine Oppong and Katharine Abu

Prepared with the financial support of the
United Nations Fund for Population Activities
(UNFPA)

International Labour Office Geneva

ISBN 92-2-105858-1
ISSN 0253-2042

First published 1987

Printed in the German Democratic Republic ZIM

PREFACE

This study is one of a series emanating from work on a global project on women's roles and demographic issues carried out in the Employment and Development Department of the International Labour Office and supported by the United Nations Fund for Population Activities. It is relevant to the widespread debates attempting to link the education, employment and urban residence of women in high-fertility countries with signs of a fertility transition.

While the precise mechanisms operating to trigger off change in fertility values and regulative behaviour are frequently admitted to be unknown, certain associations have been documented. These include the fact that in many communities women in different types of employment and with contrasting levels of education have different family sizes and varying attitudes and practices associated with birth control.

This study examines such issues and variations in one national context, Ghana. The women studied, one set from the south and one from the north, have different cultural and religious backgrounds yet have a similar range of educational and work experiences. The number of women examined here is small, only 60, but the range of data collected on each is unusually wide, allowing scope for examining a variety of hypotheses about women's changing roles and differences in child-bearing motivations and practices.

This analysis appears at a time when there is increasing interest expressed by social scientists from a variety of disciplines in "micro" approaches to the study of economic and demographic phenomena, particularly changes in fertility and mortality, and when the methods and approaches of the ethnographer are gaining increasing popularity and prestige among demographers and economists.

Behavioural and attitudinal material is used in the form of focused biographies collected from a select set of educated, urban Ghanaian women. The focus is upon the multiple interactions between their several roles, in particular their occupational role and their maternal activities of child-bearing and rearing. Sixty cases of women residing in two towns, Accra and Tamale, are compared.

Women in three age groups and from two ethnic groups - Ga and Dagomba - were chosen, including migrants and non-migrants. They provide examples of different kinds of familial institutions, patterns of parental care, migration status, urbanisation and access to employment as well as religious affiliation.

The data were collected and analysed using an early prototype of the more recently elaborated conceptual framework on Seven Roles and Statuses of Women (Oppong, 1980; and Oppong and Church, 1981, Oppong and Abu, 1985). They cover a wide area of occupational and familial life. This study concentrates on the findings related to education, migration, employment,

family size and contraception. Hypotheses are examined which relate these to women's roles - maternal, occupational, conjugal, domestic, community and individual.

The field work was mainly carried out in Accra and Tamale between May 1979 and January 1981. The data were collected during the period of the Limann regime, a period of unsure political stability, rising inflation, economic stagnation and consumer shortages. The external situation (i.e. world recession, higher fuel prices and falling cocoa prices) exacerbated the internal problems . Ghana's position was even worse than that of many other countries at this period, as the economy had already suffered years of foreign exchange deficits and inflation. The worsening economic situation was in addition aggravated by industrial unrest, which threatened to undermine the Government's efforts and eventually led to initial support for another change of government at the end of 1981.

The field work was financed by a Rockefeller Population Study Award administered by the United Nations Regional Institute for Population Studies, Legon, Accra through the good offices of the Director, Professor C. Okonjo and Dr. Vankatacharya. The research project proposal was originally designed and submitted by Christine Oppong, then a Senior Research Fellow at the Institute of African Studies of the University of Ghana, in collaboration with Dr. Christine Okali, then of the International Livestock Centre for Africa, Ibadan, and Dr. Kamene Okonjo of the University of Nigeria, Nsukka (Oppong et al., 1977). This report is concerned only with the data collected by Katharine Abu in Accra and Tamale.

Thanks are due to colleagues in the Employment Planning and Population Branch and the former Population and Labour Policies Branch of the World Employment Programme including Kailas Doctor, the former Chief, and Hélène Pour for their encouraging comments regarding the potential relevance of this monograph to current West African family welfare and planning programmes, as well as economic/demographic debates and field studies, and to Richard Anker and René Wéry for their individual insights and critical suggestions, several of which have helped to improve the presentation of this text. Comments from Rounaq Jahan, Martha Loutfi and Amarjit Oberai were also taken into account. Special thanks are due to Caryle Farley and Elizabeth Piccoli for their cheerful and dedicated application of their technical skills in the production of this text.

Contents

CHAPTER I

WOMEN'S ROLES AND STATUSES:
THE FERTILITY CONNECTIONS

1. Introduction

The primary aim of this work is to enhance the under-
standing of recent demographic and economic change processes at
the micro level in a selected West African context, focusing on
women as the central actors in the drama of change. Another
goal is to introduce greater sophistication, both theoretical and
methodological, into the collection and analysis of micro-level data
on women's roles and statuses in relation to changing educational
and employment practices and opportunities on the one hand, and
reproductive expectations and behaviour on the other. A third
aim is to call attention to the need for more knowledge about
family planning and more accessible facilities so that individuals
can satisfactorily space and plan their births.

With a view to improving concepts and techniques for data
collection and analysis, a holistic framework of roles has been
used, based upon the underlying concepts of role theory (Biddle,
1979), and incorporating seven roles women adopt in social life
(Oppong, 1980). The main method used for data collection is
that of the focused biography, which is recently once more
gaining in credibility and popularity in contemporary field work.
With regard to data analysis and presentation new modes of com-
paring and contrasting aspects of role profiles are developed.
These include simple coded indices based upon qualitative data.
The indices are used to explore at the level of the individual
woman and her roles and statuses those aspects of behaviour,
expectations and resources, knowledge and relationships, within
her particular social contexts, which appear associated with de-
clining family size, both aspirations and achievements.

In this introductory chapter some of the conceptual and
methodological problems which are the major focus of this mono-
graph are first briefly indicated: problems encountered in
attempts to link education, labour force participation and mi-
gration with differential fertility. This discussion underlines the
need, increasingly vocalised by population and development
scholars, for new types of models, concepts and data.

To facilitate an increase in the sophistication of concepts and
modes of data collection and handling and in the understanding of
dynamic interactions, a framework for analysis is introduced
which includes aspects of seven roles of women. This was
originally conceptualised for the project reported here (Oppong et
al., 1977). These issues are subsequently taken up in the
country context of Ghana, indicating the variety and change in

fertility levels and the shortcomings of earlier attempts to explain the differences and changes in terms of single variables such as education, urban residence, ethnicity and so on. Then by showing the scope of previous micro-level work in the same country, the basis for the design and development of the study described in this report is demonstrated. Next are indicated ways in which current hypotheses regarding women's roles and statuses can be systematically conceptualised and tested, using the data collected within the scope of the framework outlined.

Chapter II focuses on Ghanaian women and their roles, describing the country context of the study in more detail. A nation-wide, economic-demographic profile of Ghana in the late seventies, the study period, is followed by an outline of aspects of the roles and statuses of Ghanaian women using a variety of quantitative and qualitative source materials.

Chapter III describes the micro-level methods of data collection and analysis used here and then explores some of the major characteristics of the selected population, their ethnic affiliation, residential situation, educational experience and migration status.

Chapter IV examines the role profiles of the 60 women studied, including the women's observed and reported role behaviours and expectations and the status rewards they enjoyed. In Chapter V the focus is the dynamic aspects of roles, which became salient as the fieldwork progressed, including the innovation, conflict, strain and change, in particular as they are related to motherhood and changing attitudes and practices regarding procreation and the control of conception and births. Chapter VI briefly discusses the findings in the light of women's needs and their implications for change and policy formulation. An extensive bibliography includes sources referred to.

1.1 The problem: Models, methods and evidence

The processes through which certain socio-economic or ethnic groups or small segments of a given population consciously and purposely lower the number of children they produce, in comparison with the previous generation of their own group and more traditional sets of their peers - the sequences of events leading to demographic innovation - are currently of widespread interest. Documentation and understanding of such social processes is relevant not only to the research of demographers and social scientists and scholars of development who wish to trace the origins of population change. It is also relevant to government policy-makers and population programme administrators, who have the often almost impossible task of trying to balance national resources of various kinds and the needs of country populations (Population Council, 1981).

Alterations in the roles and statuses of women are among those critical aspects of socio-economic change frequently chosen from the array of potential intervening variables attributed to "modernisation" and "westernisation", and linked to fertility

transition.[1] Thus for example, among the pressing conceptual problems identified in a global evaluation of the impact of family planning programmes on fertility was that of, "what is meant by and how to measure, female status", given that "female status" and female age at marriage are thought to be critical components of demand both for births and contraception (United Nations, 1982, p. 21).

The two major aspects of women's "status" which have been the focus of much interest in recent years have been women's education and employment in the formal sector away from home. Some of the vast and growing literature on women's "status", education, employment and fertility has recently been synthesised and summarised by a number of scholars (Boserup, 1985; Cain, 1984; Cochrane, 1979, 1983; Kupinsky (ed.), 1977; Oppenheim Mason, 1984; Standing, 1978, 1983).

In addition migration has been viewed as a significant event leading to a relaxation of traditional sanctions and the opportunity for individuals to deviate from cultural norms.

1.2 Education and fertility

The review of a broad range of studies relating education to fertility has shown that the relationship is not as uniform as is generally believed. Indeed quite often there is found to be a nil or positive relationship. Accordingly policy-makers have been warned that any attempt to use the relationship between education and fertility for policy purposes requires a better understanding of the circumstances in which an inverse relation is likely to arise and why it does not arise in other circumstances.

Cochrane (1983), recently reviewing evidence, has noted that education operates through other variables, not directly, and that the relationship between education and fertility is non-linear. Indeed the data she reviews confirms the existence of two different patterns - the inverse pattern and an inverted "U". A United Nations (1983) study of relationships between fertility and education, comprising a comparative analysis of World Fertility Survey data for 22 developing countries, concluded that generally education has a negative effect on fertility, but not universally so and that often the relationship instead of being monotonic is hump shaped and contains an education threshold, prior to which fertility either remains stationary or increases as level of education rises. In addition, overall income levels and development stages of individual countries were demonstrated as affecting the impact of education on fertility. Countries at the lower end of the development spectrum could expect a less negative impact of education on fertility, perhaps even a positive effect, while in middle-income countries illiterate women had the highest levels of fertility found in the analysis.

The same analysis when examining rural/urban and ethnic differences also concluded that such differentials could largely be explained by differences in levels of socio-economic development.

- 3 -

Thus the results threw more doubt on the idea that increasing education simply lowers family size preferences and thus leads to reduced fertility. The findings were therefore judged to lend support to the view that raising educational levels is not of itself a device for lowering fertility. The data did however show a positive and monotonic link between education and contraceptive use.

Earlier Cochrane (1979, p. 148), following her systematic review of the literature then current, had concluded that little work had been done to determine which of the various aspects of the education process were most important in reducing fertility. As she emphasised, for the relation between fertility and education to generate policy implications, it is necessary to know not only the extent to which other factors can substitute for the effect of education, but also what particular characteristics of education increase or decrease fertility and their relative importance.

1.3 Migration and fertility

A review of hypotheses and evidence regarding connections between migration and fertility has noted that migrant women apparently desire and have smaller families after moving if certain conditions are fulfilled (Findley, 1982). These include: (a) that they are young at the time of migration; (b) that they delay first union or experience lengthy marital separations (factors, of course, only operative if the majority of births are within unions); (c) that they are better educated and take advantage of urban opportunities; (d) that their jobs are incompatible with child-rearing; (e) that they have modern aspirations for their children, including schooling costs which raise the price of children – educated migrants are also noted more likely to pursue "an urban life style"; (f) that they interact with reference groups who have low fertility norms; (g) that they experience fewer child deaths; (h) that they are less reliant on children for help; (i) that they are part of a culture with openness to modernisation and change; and (j) that they are aware of and can obtain contraceptives. Thus Findley (1982) concluded that through education and residence in a city a migrant woman may be more likely to develop desire to limit births and to move into a situation where such limitation is feasible, supported and advantageous.

There are, however, other dimensions of potential migration impacts upon fertility which involve much more sophisticated conceptualisation of the possible change processes. This takes into account the potential changes occurring in familial roles, including impacts of migration or urban living upon: (a) the constraints to innovation often associated with close kin ties and dependence of the child-bearing generation upon powerful and authoritative elders; or (b) the additional resources for child-care associated with the support which may be forthcoming from

co-resident or nearby kin; and (c) the impacts of mobility and heterogeneity of social life upon conjugal roles, leading to the possibility for more joint, companionate and egalitarian forms of interaction, which may have subtle effects upon the child-bearing aspirations and capacity to plan births.

Again "exposure to urban life styles" and "openness to modernisation and change" may, one presumes, involve more opportunities for individual participation in community (non-familial) activities, for friendship with peers and enjoyment of modern leisure activities and pursuits, all of which have been in different contexts hypothesised and sometimes demonstrated as being linked to lower fertility desires and practices. These hypotheses and examples of relevant evidence will be discussed below.

1.4 Women's work and fertility

With regard to women's work, a simple view expressed frequently and supported with large and expensive data sets has been that fertility is inversely associated with women's labour force participation, leading two decades ago to the idea that expansion of female employment would lead to fertility reduction. However, empirical analyses have repeatedly demonstrated - and consequently the realisation has grown - that this relationship is complex and depends upon the extent to which work and child-rearing are in conflict or compatible (Standing, 1978). Thus in agricultural areas there might even be a positive relationship and "white collar work" is not necessarily associated with lower fertility (e.g. Kasarda, 1971, an analysis of data from 60 countries; and Ware, 1977, on Nigeria).

As Standing (1983) has emphasised, the conflicting and diverse evidence indicate that the elements constituting "role incompatibility" call for improved definition and require evidence not usually available in employment data. Factors leading to incompatibility of the two roles include distance of work from home, length of the working day, availability and acceptability of child-care support and so on. Obviously this is an area for more sophisticated documentation and analysis. In fact, serious attempts have been made to index and compare (using scales) the kinds of strain experienced by employed mothers in attempting to cope with both domestic and paid work (e.g. Parry and Warr, 1980). Full-time employed mothers have been found to report significantly more strain than part-time employed mothers. Thus, in the study reported here some attempt was made to examine several quantifiable components of maternal/occupational role incompatibility, including degrees of separation of work and home, length of the working day and availability and acceptability of child-care substitutes.

1.5 A need for new models, concepts and data

Thus far we have indicated that earlier work attempting to establish statistical associations between single variables - levels of education, employment or migration status - and fertility levels has often been disappointing and inconclusive or has varied according to socio-economic context and level of development. The need has been expressed, as noted in several attempts at synthesis, to document and incorporate new types of data on women's various roles - as workers, as wives, as kin, as urban community dwellers - in order to see how precisely these roles are changing, how they vary in different contexts and how they are having an impact upon the role of mother. In particular, interest is frequently expressed in documenting the contexts and consequences of role conflicts and strain. Hence the recently emphasised need for new types of data and new approaches to the conceptualisation and measurement of women's roles and statuses, which would enable the effects of education and migration and different types of employment to be more precisely documented. For example, attention has been called to the need: (a) to examine women's time use and its allocation to the activities associated with different roles (Mueller, 1982); (b) to realise the cross-cultural diversity of family forms and the fact that such diversity, in terms of divisions of labour and responsibilities, is closely related to the allocation of costs and benefits of child-bearing and rearing (Oppong, 1982a); (c) to examine the divisions of labour inside the home as well as outside (Youssef, 1982); and (d) to look at the sources and uses of female resources and power (Safilios-Rothschild, 1982). In addition the need has been stressed to examine women's roles at different points in the life cycle and in terms of their development from youth to maturity (Epstein, 1982).

More recently the need to incorporate familial links centrally into any model of change has been restressed and the usefulness of linking education or training and work and migration to child-bearing and rearing patterns, through changes in parenthood, marriage and kinship has been supported by global evidence (Oppong, 1983b). Such an approach demands a systematic framework in which multiple effects operate simultaneously. It also involves a much more dynamic approach in that it includes comparison of resources and their effects on power and choice, role conflict and strain for individuals and interpersonal conflicts between spouses, kin and parents and children. It also needs to incorporate the availability of opportunities for, and evidence of, innovation or deviance and changing aspirations and relaxing of customary constraints.

1.6 The seven roles framework

Thus it was decided before the data analysed here were collected that though the study was ultimately concerned with women's role as mothers, there were six other roles of women which should also be considered in order to understand such changes and their altering expectations and activities as child-bearers, if a holistic and integrated picture of women's lives were to be drawn. Thus a conceptual framework of seven roles of women was outlined (Oppong, 1980).

The design was such that information collected would pertain to seven roles women play during their lives including: (1) maternal, (2) occupational, (3) conjugal, (4) domestic, (5) kin, (6) community and (7) individual. Information to be collected relevant to these several roles included activities associated with a particular role, the resources in time, knowledge and material goods/money accumulated or spent, the attached power and decision-making and the significant people vis-à-vis whom she plays the role and the content of their relationship with her. The methods of data collection, classification and analysis are described in detail in Oppong (1983a), and Oppong and Abu (1985).

The information on activities, resources and social relationships could be used:

(a) to assess relative levels of material (money and goods), social (influence, prestige) and political (power) rewards accruing from a particular role and therefore the kinds of economic, social and political status it conferred;

(b) to compare role conflict or harmony - the extent to which activities and related goals were in harmony or incompatible and the kinds of stresses these might cause;

(c) to assess relative availability of resources to fulfil role demands and consequently estimate feelings of role strain, if they were perceived as inadequate or insecure.

The data on role expectations included prescriptions (norms or customs and laws), values (preferences and assessments) and perceptions (beliefs and representations). This information facilitated among other things the assessment of:

(a) role satisfaction: rewards from different roles could be viewed in terms of the satisfaction which the woman concerned was perceived to experience or, on the contrary, her lack of satisfaction could be estimated and consequently seen as a spur to change or deviant or innovative behaviour;

(b) role priority: roles could be ranked according to the seriousness or single-mindedness with which women pursued

particular associated life goals (such as child-bearing or income earning). (See below, pp. 46-47).

It was intended that the collection of these sets of data would make possible multi-dimensional insights into the lives of the women concerned as well as providing appropriate data for the generation and possible testing of a range of hypotheses. The central focus of attention was women's maternal role and the effects on this of their other role activities and expectations as workers, wives, and so on, and as members of particular cultural and social environments.

The social context - Ghana - in which the data were collected is the next topic covered. Local problems apparent in the understanding of demographic data are noted, in addition to the pointers which existed in a number of earlier studies to innovative modes of analysing data to enhance understanding of change.

2. The Case of Ghana: Fertility Contrasts and Changes

In Ghana, as in the rest of Africa, family size ideals and achievements remain among the highest in the world.[2] Numerous, now classic ethnographic studies of agricultural communities and households in different ethnic areas have documented in great detail the traditional cultural and socio-economic contexts of such high fertility.[3] They have indicated the high demand for agricultural and domestic labour in subsistence economies with primitive production techniques. They have described the general availability of land for farming in a relatively sparsely populated country and the high levels of infant and child mortality and general vulnerability to tropical diseases in communities with limited access to modern medical care. All of these factors have facilitated and encouraged repeated and prolonged child-bearing and begetting. This general pattern of reproductive activities has been described by Ware (1983) for West Africa as a whole. In addition the proximity and solidarity of kin and practices of fostering have traditionally assured the availability of multiple parental figures, who may all share the responsibilities of childcare and enjoy the benefits of child labour (E. Goody, 1982).

During the past two decades, however, demographic enquiries in Ghana have noted increasing contrasts in fertility between different categories of the population by employment status, ethnicity, income level, educational standard and size of community of residence. Many tabular analyses of fertility have been undertaken documenting these differences and often taking more than one factor into account, for instance education and urban/rural residence, or type of employment and urban/rural residence.[4] While certain contrasts are clearly apparent in the wider population (for example, farmers tend to have higher fertility than the rest and the highly educated to have relatively

- 8 -

fewer children, and rural/urban differences persist overall), yet when more refined analyses are undertaken and several factors are taken simultaneously into consideration, differences between particular categories by education, employment, residence and so on, are not always in the expected direction. Ghanaian demographers have openly admitted the difficulties involved in providing explanations for such differences (e.g. Gaisie and Nabila, 1978). Simple one-factor explanations of differences are recognised as inadequate, and moreover they tell nothing about the causes, processes and consequences of change.

In the 1960s, Caldwell (1968) documented the relatively lower family sizes of the urban educated, attempting to demonstrate socio-economic causes for demographic innovation. Later, Gaisie (1976) contrasted urban and rural fertility differences. Yet he contended that the real size of the urban-rural fertility difference was masked by a plethora of complex factors not adequately covered by the available statistics and pointed to the need for further study of urban fertility patterns. Similarly in the case of differences by education, Gaisie and Nabila (1978)[5] noted that the total fertility rates for women in the three educational categories nil, primary and middle school were 6.6, 6.9 and 6.5, indicating a slight rise among the primary school attenders. They thus concluded that formal education had a negative effect on fertility only within certain social situations where other supportive or contributory factors were operative. In other words the precise factors and processes contributing to differences and change were unknown and undocumented.

Again regional differences recorded have been attributed to demographic-economic factors such as migration, malnutrition and disease rather than distinctively cultural features for want of other explanations.[6] More recently the effects of such customary behavioural differences as post partum abstinence have been considered (Gaisie, 1981).

A contrast which remains quite clear is that between people engaged in agricultural pursuits who have the highest levels of fertility (an average of six to seven children) and people employed in the organised sector of work separate from the home who have the lowest fertility (an average of three children). Among both of these categories, however, there is considerable variation and included among the high fertility category are women self-employed and with employees and family workers, who trade as well as engaging in agriculture. Thus among women a major contrast is between the fertility regimes of the small percentage of women employed as secretaries, teachers, typists, nurses and so on, in government institutions, and women who are traders and farmers working on their own account or in family concerns.

2.1 Micro approaches: Roles, relationships and resources

This diversity and change in the reproductive behaviour of the educated and employed, mainly in urban settings, has been the focus of concern in a series of micro-demographic studies spread through the past decade and a half using a variety of materials for analaysis, ranging from reported behaviour and normative prescriptions documented through postal questionnaires, to focused interviewing, personal observations and case studies. This work has recently been summarised and the implications for future research underlined, in terms of concepts and methods of data collection and analysis (Oppong, 1985a). The female and male employees studied included nurses, clerks, teachers and others in government service, as well as students and farmers. Many were first generation educated urban migrants. Measures of change in familial roles and relationships, including the conjugal, parental and kin roles, were noted using a methodology developed in an earlier study of changes in domestic life among the urban educated (Oppong, 1982b).

Data on both role expectations and behaviours supported contentions that increases in individual parental costs in either time or material goods, whether caused by decreasing delegation of these to kin and others, spouses not sharing costs or higher demands in terms of children's education and so on, led to reduced family size desires. At the same time role conflicts caused by separation of work and home, in contexts where it was difficult to delegate child-care, were also associated with parental role strain and reduced demand for children. Such strains and conflicts were found in data from both mothers and fathers and from prospective parents. Changing patterns of work as well as the scattering of kin through migration were noted to be among the structural changes affecting occupational and kin roles, which in turn affected the costs and benefits of parenthood. Higher aspirations for self and offspring were also related to changing parental goals. High fertility supports were observed to be crumbling among the mobile, educated and employed. Responsible fathers perceiving more individualised demands upon their resources in time and money were observed to feel a sense of strain and to lower their family desires accordingly (Oppong, 1983b and forthcoming). There were several types of data sets from different selected populations which all supported a variety of hypotheses linking lower family size desires and more systematic birth control with personal parental responsibility, individualism, growing equality of parents and children, and increasingly flexible divisions of tasks, responsibilities and power between spouses.

The position of the individual with respect to kin was found to be critical and to vary significantly according to whether she or he was first, second or third generation educated and socially and spatially mobile. Thus the effects of migration were also taken into account in so far as they affected the solidarity of kin and the expectations and exchanges associated with their relationships.

These studies concentrated upon familial roles, however, and few data pertinent to community roles and individual leisure and pleasure pursuits were systematically collected, even though changes in these roles have been hypothesised and demonstrated to be relevant to fertility and have been well documented in other parallel studies (e.g. Dinan, 1983). It was therefore decided to build upon and expand this earlier work using similar concepts and hypotheses but extending the roles considered to seven as outlined above, and simultaneously to collect more detailed data and data of different kinds, including information which would give more insight into changing values and role priorities affecting motherhood, especially those affecting perceived costs and opportunity costs of children. It was intended in particular to try to index and compare levels of role strain and conflicts between different roles and also to look at the issues of role satisfaction and gratification in relation to the array of potential and observed rewards or status benefits which women appeared to enjoy and benefit from.

2.2 Parenthood: Changing resources, expectations and conflicts

On the basis of the micro-level studies referred to we may now specify, in more systematic detail, ways in which education (levels and generations), migration and occupational role attributes may be linked to potential changes in one or more of a person's roles and ultimately have an impact upon parenthood and consequently fertility-related expectations and practices. Since migration is so closely associated with education in the Ghanaian context, we shall view these simultaneously as aspects of social and spatial mobility.

2.3 Education

With regard to education and the commonly associated spatial movement, the new resources and opportunities it opened up to the individual during the decades of the sixties and seventies should be considered, including the removal of traditional sanctions and relaxation of customary constraints, the potential effects of these on various roles and how these in turn may be linked to the lowering of fertility aspirations and achievements.[7]

(i) literacy: the ability to read facilitates access to information and the availability of new types of knowledge through the printed word. It may also involve the learning of a new language and the ability to understand a range of news and views. This is likely to enhance the possibilities for information processing relevant to all seven roles and to facilitate participation in a wider range of activities. It will in particular affect parental knowledge and the potential ability to use contraception and to improve child health through family planning and medical information.

- 11 -

(ii) skills: employable skills, and occupational knowledge learnt in school will lead to openings for jobs and the ability to earn an income in the modern sector of the economy, thus affecting the potential resources which may accrue to individuals from their occupational role. Individually earned income may enhance personal resources, autonomy and influence in other role spheres including the parental, conjugal and domestic. If separation between home and work are involved this may lead to potential role conflicts.

(iii) school certificates: certificates and diplomas from levels of schooling attained are likely to enhance social status and social position (deference, prestige) and increase expectations for a more costly life-style which may involve a more expensive form of marriage (wedding costs) and may involve higher expectations for one's own children and thus a costlier upbringing for them, involving increased parental costs.

(iv) socialisation: the new expectations and behaviour patterns learnt at school in a non-familial environment, which tends to be competitive, may encourage individualisation of goals and behaviour patterns. It may foster the courage and propensity to deviate from tradition and to innovate, and may enhance skills for leisure spending and individual gratification, by encouraging friendship ties outside the kin network and the formation of peer groups supporting new goals and practices. It may also encourage the propensity to participate in community activities.

(v) social mobility: education beyond levels achieved in the parental generation may involve social mobility and opportunities for advancement up the socio-economic scale as part of a process of class formation. The individual may be in a position through the new income and life-style involved to accumulate individual property and achieve a sense of individual security, which may be accompanied by a loosening of economic ties involving dependence upon or maintenance of kin.

(vi) spatial mobility: schooling and the types of occupations it leads to may be closely connected with spatial mobility and thus increased distance from kin and home community, leading to a decrease in kin solidarity in social and economic and affective terms, and a decrease in control or pressures from kin. Such changes may enhance opportunities for individualism, innovation and deviance, including new parental values and goals. At the same time separation from kin for parents may involve an increasing individual assumption of parental responsibilities, which can no longer be easily shared with co-resident or neighbouring kin.

Moreover, migration from kin, in contexts in which segregation of conjugal roles is the traditional norm, may involve pressures and opportunities for closer, more companionate, and

more egalitarian and communicative conjugal relations, an effect not only found in previous sets of Ghanaian data but reported in a diverse array of contexts. [8]

(vii) relative power: education has also been examined as a source of relative power vis-à-vis the spouse.

Earlier studies in Ghana and elsewhere have clearly demonstrated that educational attainment is a conjugal resource with potential effects upon conjugal power and decision-making, being closely associated with earning potential and actual income (Oppong, 1970). Spouses' relative levels of education are found to be associated with the incidence of spouse dominance or equality, which in turn are linked to patterns of divisions of domestic labour (Oppong, 1982b). A more powerful spouse may be better placed to achieve personal family size desires.

There are, thus, multiple aspects of potential effects on all roles of social and spatial mobility occurring through education and migration, each of which has possible implications for parenthood, its associated expectations, resources (knowledge, money, control of labour), power and activities.

2.4 Occupations

With regard to occupational opportunities and activities, several important aspects have already been spelt out which need to be taken into consideration when role conflict or incompatibility between the maternal and occupational roles are being examined. These include: distance between work and home; length and flexibility of the working day; availability and acceptability of child-care support; and of course whether children may or may not accompany the mother in her place of work.
These aspects of the degree of incompatibility or congruence between roles and their relative priority as sources of economic and social rewards (or status) also need to be taken up, and this occurs as the evidence from the women studied is examined.

2.5 Summary comment

The conceptual and methodological issues which are the focus of this study have now been identified. The shortcomings of much previous large-scale work using aggregated statistics on education, employment and fertility have been indicated. A framework for the collection and analysis of micro-level data, both qualitative and quantitative, has been described. This facilitates the more systematic and sophisticated examination of data relevant to the causes, processes and consequences of change in economic and demographic behaviour and aspirations. In addition, the dimensions of the issues within one national context, that of

Ghana, have been noted. The difficulties encountered by demographers during the decade of the seventies have been indicated, as they attempted to explain and understand the variations and changes observed in fertility levels and regulation practices in different subsets of the overall population. The scope of several sets of micro-studies, using a variety of research techniques for data collection and analysis, has been indicated. Such approaches lead to a more systematic and dynamic consideration of change processes within familial role systems and the testing of an array of hypotheses linking changes and conflicts in familial and occupational roles to demographic innovation. In particular it has been indicated how these role changes may be linked to aspects of educational opportunity, occupational change and migration and social mobility. Many of these hypotheses have been systematically spelt out and supportive data cited in Oppong (1983a).

In the next chapter, as a background to the presentation of case materials, the economic and demographic context of Ghana and the situation of women in particular is considered, including an overview of their different role expectations, resources and activities. This context is the decade of the seventies, which immediately preceded the collection of the biographical data subsequently examined.

Notes

[1] The plural form 'statuses' is used here because in the conceptual framework on seven roles, economic, social and political status rewards are associated with each of the roles facilitating a more complex formulation of issues and more precise definitions of particular status indices, e.g. maternal economic status - material rewards of various kinds accruing from children.

[2] No survey of a general population in tropical Africa has reported a mean family size of less than five and several have shown levels of seven which have never been recorded elsewhere (Ware, 1975).

[3] See for example, Fortes (1949, 1950, 1954); E. Goody (1973); Nukunya (1969).

[4] Thus, for instance, in Kumasi levels of recorded total fertility rates have ranged from 4.3 in the middle and upper socio-economic status residential areas to between 6.4 and 7.1 in the low socio-economic areas respectively (Gaisie, 1976, p. 84). If communities of three types are examined by size and completed family size, total fertility is seen to decrease with size of community with the result that it has been stated that a woman residing in a rural community with a population of less than 2,000 tends to be more prolific than her counterparts in a suburban area.

[5] Using data from the 1971 supplementary census enquiry.

[6] High fertility peoples in Ghana include the matrilineal Akan in the southern regions. The moderately high fertility groups include the coastal Fante, Akwapim, Ga and Ewe. The low fertility groups include the Frafra, Kusasi, Konkomba and Dagomba in the northern regions (Gaisie, 1976).

[7] Cochrane (1979) attempted to separate out different aspects of educational impact but did not use a role perspective.

[8] See for example the work on the Sudan by Richard and M. El Awad Galal el Din (1982) and the earlier work of Rosen and Simmons (1971) and Rosen (1973). For example, Rosen's (1973) observation of family interaction among 167 lower class Brazilian families revealed that with longer periods of city residence migrant families became more egalitarian, family relations became more open and responsive and parents placed greater emphasis on achievement and independence for their sons. He also remarked that the communication patterns of migrants differ, being freer and more enjoyable. Again he remarked greater parental involvement in children's tasks.

CHAPTER II

GHANA AND GHANAIAN WOMEN

1. The Country Context

1.1 The economy

Ghana with a population estimated at the time of the study as some 12 million or more, was formerly one of the richest countries in tropical Africa (per capita income in 1970, US$ 262) with an economy based to a large extent upon the export of cocoa, timber, industrial diamonds, bauxite, manganese, dioxide, coffee and gold. Cocoa and timber have for a long time been the major exports, but have recently dwindled drastically in amount and importance.

For over 400 years, communities on the coast were affected by international trade and a market economy. Merchant companies from Europe built forts on the coast to carry out their trade in slaves and gold and later in palm oil nuts and rubber. These trading settlements, including Accra, were the focal points for migrant settlers, some of whom had opportunities for technical training and education and became a small elite.

Until the last decade of the nineteenth century the Gold Coast, as it then was, had an economy dominated mainly by traditional agriculture, crafts, hunting and gathering and trade. Technology was simple and modern types of industrial activity were confined to the coastal belt and a small gold mine at Tarkwa. Within a period of 20 years, however, the country became the biggest exporter of cocoa in the world, gold mining flourished and railways were built. The pattern of the economy established by the first decade of the twentieth century was largely still in existence in 1960. The rapid expansion of the new cash crop was noted to be facilitated by people with long experience in commercial activities.

In the decade of the sixties following Independence, Ghana enjoyed a relatively high standard of living in comparison with many other countries of the West African region. But in spite of attempts both to industrialise and to mechanise agriculture, there was during the 1960s and 1970s a phase of stagnation and sharp decline in real incomes (Bequele, 1983).

In the 1970s, the gross domestic product and per capita incomes declined and at the same time inflation soared and the value of the local currency, the cedi (\mathcal{C}), plummeted. (The cedi, which was originally worth £0.50, was by the end of 1980 officially equal to £0.15 but its black market value was £0.03.). Hyperinflation reached alarming proportions. Between 1972 and 1975, according to one index, inflation was running at 40 per cent

per year and subsequently went past the three-figure mark. Among the causes of economic decline and stagnation identified were low levels of productivity in the few industries which survived and the several levels of retailing. Many able-bodied people, especially women, remained involved full or part-time in the unproductive but lucrative work of buying and selling (see Bequele, 1983).

By mid-1978 large budget deficits, an increasing money supply and a greatly over-valued currency led to inflation of 125 per cent. In addition, poor rainfall, low prices for agricultural produce, lack of fertilizers and machinery reduced agricultural production and exports. At the same time manufacturing was hindered by lack of imported raw materials and spare parts and per capita income declined to below the level of 1970. Nearly 12 per cent of the labour force was recorded as unemployed (United States Department of Labor, 1980). In addition the brain drain of skilled and professional workers to neighbouring countries in particular had already begun leading to a chronic shortage of higher-level manpower. Between August 1977 and September 1978 alone, 4,000 teachers left the country (ibid.).

By the beginning of 1979, when the data collection for this study began, shortages of consumer goods considered essential, such as sugar, rice, milk, flour, soap and batteries remained chronic and queueing had begun to constitute a way of life. Production was at a low ebb because of shortages of raw materials, machinery and spare parts. In addition the construction industry came to a halt because of shortages, while the timber industry was in a state of collapse (see Economist Intelligence Unit, 1980).

Formerly the world's greatest producer of cocoa, by the end of the 1970s Ghana was producing half what it had been in the sixties. By 1980 it was contributing only about 18 per cent of total world output, the crop being half the level of 25 years earlier, allowing Brazil and Côte-d'Ivoire to move into first and second place as world producers.

Labour unrest during 1980 occurred in an economic context in which fish was selling at ₡10 per pound and a single egg cost ₡1.50 and yet the daily minimum wage was still only ₡4 (US$1.45) rising to ₡12 later in the year after trade union demands for ₡30 (Economist Intelligence Unit, 1980, p. 9) (see figure II.1, which shows the rising cost of living).

In 1980 the black market exchange rate of ₡30 to £1, as compared to the official rate of ₡6.5, showed the demand for foreign exchange, as well as supporting the argument that the cedi should be devalued. Manufactured goods were hard to come by even at inflated prices and "kalabule" or black marketeering was increasing and queues for commodities less orderly. By early 1981 a loaf of bread was selling at 60 per cent above the official minimum daily wage, the inflation rate had exceeded 100 per cent - indeed reached 130 per cent - and the cedi was being traded at one-fifteenth of its official level. Strikes during the period

further dislocated production, reported to be running at 25-50 per cent of capacity, and unemployment was conservatively estimated to be 20 per cent.

In view of this escalating economic crisis it is hardly surprising that during the study women complained bitterly of new and unaccustomed economic hardships and repeatedly referred to the problems of feeding and clothing their dependent family members. Nor is it surprising that so many, as will be seen below, were seriously dedicated to the task of earning incomes and trying to increase their purchasing power through taking on second jobs and improving their career prospects.

Figure II.1. Cost of living in Ghana 1979-81

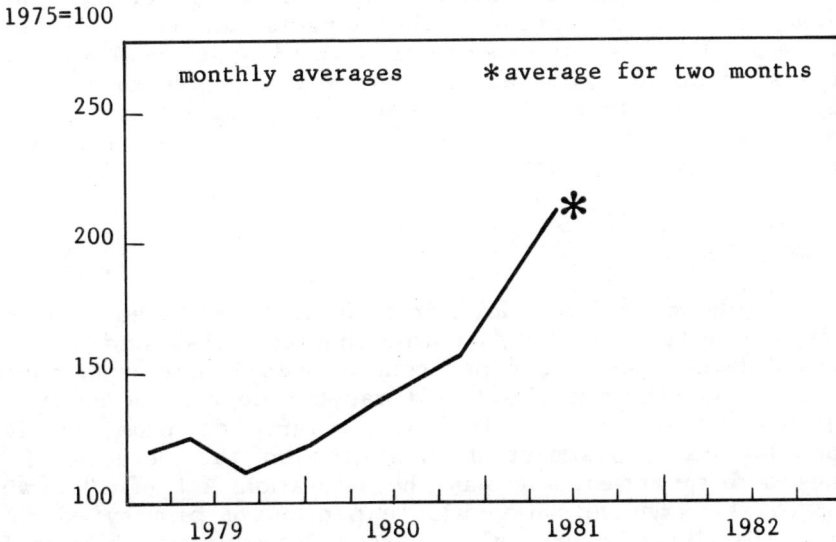

1975=100

Source. Quarterly Economic Review of Ghana, Sierra Leone, Gambia, Liberia (London, Economist Intelligence Unit), 4th Quarter, 1981. Economic trends in Ghana, Sierra Leone, Gambia and Liberia (London, Economist Intelligence Unit), 1981, from p. 22.

1.2 Social and spatial mobility

As well as being remarkable for its former relative prosperity and in comparison with its economic decline, Ghana has also been outstanding among West African countries for the educational levels and urbanisation of its population. The widespread incidence of rural to urban migration in Ghana has been

documented in some detail for the sixties (Caldwell, 1968) and attention drawn to the fact that migrants have a tendency to be educated elements of the population, leading to strong links between social and spatial mobility. The shift of the population from rural to urban areas was clearly shown by the expansion of the five main cities between 1960 and 1970. Accra, the coastal capital, grew by 5.4 per cent to 738,498 and Tamale, then the main town in the north, by 7.5 per cent to 80,000.

Already by 1971 the urban population (that is in communities with populations of 5,000 and more) totalled 2.6 million and the rural population 6.3 million. By 1980 the proportion of the population classified as urban was estimated at 37 per cent.

The widespread rural-urban migration, however, cannot be simply attributed to the process of industrialisation for the proportion of the population engaged in industrial production has remained relatively small and concentrated in the Accra Tema area. Educated people travelled to work in government institutions and have remained the largest single category of employees, that is civil servants (including clerical workers), teachers, hospital staff, administrators and professionals.[1] In addition, traders travel to buy and sell. People travel to towns to stay with kin and look for work and children are sent to relatives in town to attend school.

1.3 Education

The phenomenal rise in literacy in the past three decades or so is illustrated by the fact that between 1948 and 1970 the recorded level rose from 4 per cent to over 43 per cent, and the successive governments have had varying degrees of commitment to provide free and compulsory elementary education, involving major financial investment in this area in the decades of the sixties and seventies. It was the Education Act of 1961 which heralded the massive nation-wide expansion of primary education during the Nkrumah era, when elementary education became free and compulsory. However many difficulties were encountered in enforcing this in rural areas, especially among girls.

A study during the sixties among the northern muslimised Dagomba showed the reluctance of parents to send their children to school, especially girls because their labour was needed in the home and on the farm and on account of fears that marriage prospects would be spoilt and loose ways learned (Oppong, 1973). The kinds of compulsion which had to be exerted were described, including political pressure through local chiefs and elders.

More recent studies have highlighted the high drop-out levels among girls (Campbell Platt, 1982). In the south the latter have been attributed to lack of financial support from parents and thus the need to work and earn money, and to unplanned pregnancy (Akuffo, 1982 and forthcoming). The drop-out rate of girls from school among the Ga of Accra has been explained by the fact that mothers want their girls to help at home and in the

Table II.1. Percentage literate, aged 15 years and over by sex, 1971

Age	Both sexes	Male	Female
Total, 15 years and over	30.2	43.1	18.4
15 to 24 years	53.6	68.6	36.6
25 to 34 years	28.8	46.6	14.3
35 years and over	13.7	22.7	5.0

Note. In order to ascertain information on literacy, the question asked was "Do you know how to read and write any language?"

Source. United States Bureau of Census (1977), p. 9.

Table II.2. School attendance of females 15 years and over by region

	In school	Completed schooling
All Ghana	5.5	17.2
Western	5.1	17.3
Central	5.5	14.5
Greater Accra	7.5	38.1
Eastern	7.7	22.9
Ashanti	7.1	20.1
Brong Ahafo	5.0	13.4
Volta	6.9	19.6
Northern	1.0	2.5
Upper	1.2	2.4

Source. Ghana Population Census Report (Accra), Vol. 2, 1972, p. xiii.

market - the girls are perceived as needing practical skills (e.g. Robertson, 1977). The result is that at the higher levels of education and training women form a very small percentage, especially in courses traditionally considered male, such as engineering. In the seventies, girls formed only 26 per cent of students in all forms of post-elementary education and less than one-third of students in public commercial schools and teacher training colleges.

At the same time the overall gap in literacy between women and men remains wide. In all age groups far more males than females are literate, even though the proportion literate for both sexes has increased rapidly in recent decades (see table II.1). In addition, patterns of school attendance have varied considerably in different regions, especially for girls, and particularly in the Northern and Upper Regions attendance rates have lagged far behind the rest of the country. Table II.2 illustrates the dimensions of the contrast, showing that the greatest difference in the percentage of educated women is between the capital district of Greater Accra and the Northern Region where Tamale is situated. In the former in 1970, over 38 per cent of females were in school or had been to school, while less than 2.5 per cent of women in the Northern and Upper Regions had been to or were at school.

Between 1961 and 1973 enrolment in primary schools rose from 641,700 to over one million and secondary school enrolment expanded from less than 20,000 pupils to over 60,000. Perhaps it is not surprising to note that secondary school students were drawn to a large extent from the high-status urbanised sectors of society, with an over-representation of children of professionals and semi-professionals (Weis, 1983). Thirty-six per cent of secondary school students in 1974 were children of professionals or semi-professionals compared to the 4 per cent of the adult population in this category. Similarly urban dwellers have been proportionately over-represented. Both of these trends were observed in the late sixties in surveys among university students (Oppong, 1975, etc.). Weis (1983) has demonstrated that the relationship between student social background characteristics and quality of school attended became more pronounced as the system expanded, indicating signs of the emergence of a more rigid and closed class structure than had existed previously. As will be seen, educated parents have been increasingly aware of this fact and have striven to ensure the entry of their children into elite secondary schools by one means or another, placing a high value upon academic achievement and entry into the professions, which in the sixties and seventies led to incomes far above those of the labouring poor, though not necessarily higher than those of successful traders and entrepreneurs.

1.4 Employment

The majority of both adult men and adult women are farmers, and for women trade is the next most common form of employment. In 1960, 89 per cent of males and 57 per cent of females aged 15 and over were reported to be economically active, while in 1970 the proportions were 84 per cent and 64 per cent respectively. However, these official census figures disguise two facts: the significant proportion of women working productively within domestic settings, whose work is not recognised by the census taker, and the proportion of children under 15, both in and out of school, actively engaged for several hours a day in agriculture, trading and crafts, and domestic work - some as wage earners and others as unpaid family labour.[2]

The proportion of the labour force engaged in farming and fishing declined from about 62 per cent in 1960 to 57 per cent in 1970. During the same period there was an increase in workers labelled professionals, technical workers and production related workers and service workers from 16 per cent in 1960 to 28 per cent in 1970. Only 23 per cent of men and 15 per cent of women were by this time engaged in production and transportation as operators and labourers.

The upper echelons of the professional, technical, and administrative and managerial posts are dominated by men. Only 3 per cent of economically active women were classified as professional, technical or clerical workers in the public or private sectors of the economy in the 1970 census. They do however form a large minority of the semi-professionals (teachers, nurses and others).

With the increased growth of the population and the spread of education, the literate labour force expanded and consequently the demand for paid employment. From 1960 to 1970 opportunities for employment expanded at about the same speed as the labour force by about 2.1 per cent per annum and the female labour force participation rate rose in spite of industrialisation (Steel, 1981). The unemployment rate persisted at the estimated average of 6 per cent through the period. This unemployed population increased in the seventies concentrating in certain age groups, with 25 per cent of the 15-19 age group reputed to be jobless. The rate became even higher for males in urban areas, especially Accra.

1.5 Demographic situation

Ghana, like most of the West African States, is a country with a high birth rate which shows scarcely any signs of overall decrease; a relatively high death rate, with only little evidence of a drop, which may more recently have taken another upward turn and a high, even increasing, rate of growth (see table II.3). The outcome is a population with a median age of under

17, a high dependency ratio of 937 per 1,000 and a life expectancy for males of 47 and for females of 50.

Table II.3. Demographic conditions in Ghana, 1975-80

	Birth rate (per thousand)	Death rate (per thousand)	Population growth rate
1975	49	22	2.7
1976	49	22	2.7
1977	47	20	2.7
1978	49	20	2.9
1979	48	17	3.1
1980	48	17	3.1

Sources. Abate (1980), p. 31.

1.6 National population policy

Ghana published a comprehensive population policy in 1969 and set up a National Family Planning Programme in 1970. An objective of the policy included reduction of the rapid population growth, to slow it down to 1.8 per annum by the year 2000 and from the beginning the Ghana National Family Planning Programme (GNFPP) set targets for numbers of contraceptive users, but achievements fell far short of goals. However, by the end of the 1970s a certain amount of success had been achieved and particularly for the educated in urban areas, contraceptive supplies and information were readily available in clinics and commercial outlets.

In the guide-lines for the Five Year Development Plan (1975-80), the Government stressed the view that a high birth rate had become a constraint to health, which it considered to be one of the primary requirements for economic and social development. It also indicated the desire to reduce population growth through lowering fertility and drew attention to the importance of the services for family planning and maternal and child health. Perceived as part of the Government's policies to lower fertility were their promotion of the status of women, through education and employment opportunities, and restriction of maternity benefits and child allowances to three births only.

Now having briefly outlined some of the economic and demographic aspects of the Ghanaian situation with particular reference

to the period of the study - the end of the decade of the seventies - we shall go on to examine existing data of various kinds on the several roles of Ghanaian women, especially as workers and mothers, and see how these roles tend to vary with education, migration and urban living. This discussion forms a background to our subsequent analysis of the 60 women studied in detail.

2. Women's Roles

Compared with women in many other parts of the world, including industrialised countries, Ghanaian women have played a comparatively active part in economic life, especially trade and agricultural production, as well as having one of the highest fertility rates in the world. In addition Ghanaian women have been ranked high on scales measuring individualism and status vis-à-vis men and have been perceived as relatively confident and ambitious by their children, just as Ghanaian fathers have been perceived as relatively expressive (McIntyre et al., 1974). It has been argued, however, that women's power in Ghana has in the past two decades been eroded for some groups of women. This has occurred through their relatively restricted access to two strategic resources, education and land. For many it is occurring because of the growing structural ambivalence, as mothers' productive work is increasingly spatially separate from the home, reproduction and socialisation, i.e. maternal/ occupational role conflicts are increasing (see Oppong et al., 1975).

Aspects of their roles and resources have been documented by small-scale anthropological studies using ethnographic techniques, as well as by demographic and economic surveys. The National Council on Women and Development (NCWD) since 1976 has sponsored a number of studies of women's work, education, training and family issues, which are relevant to the design and execution of government policies and have highlighted ways in which girls and women are relatively deprived in relation to boys and men as regards access to school places, vocational training opportunities, promotion to decision-making posts in government bureaucracies and access to credit. (NCWD, 1982). Moreover, women have been relatively neglected in terms of documentation, being omitted from consideration in important surveys of agricultural activities, and much of their informal productive and income-earning activities remain as yet unrecorded in official statistics.

2.1 Workers

The overall economic situation and employment picture have already been briefly sketched. The data on labour force activity for women, as in many countries of the world, need to be treated

with caution because of the potential understatement of the work of women in domestic and informal settings. Even so, as was noted, the figures show a continuing high participation rate for women, especially in the age groups of the thirties and forties, the time of the life cycle when women are still child-bearing and also caring for their several children already born. These rates are equally high for both rural and urban areas (see table II.4).

Table II.4. Female population aged 15-49: Labour force activity rates by urban/rural population, 1970

Age	Total	Urban	Rural
15-19	63.6	62.7	63.9
20-24	39.2	35.8	41.0
25-29	61.4	61.1	61.5
30-34	71.5	73.5	70.7
35-39	73.9	77.0	72.8
40-44	77.9	80.5	77.0
45-49	77.9	81.0	77.0

Source. Data assembled by the Ghana National Council on Women and Development, 1977. Accra, mimeographed.

The bulk of women's labour is in agriculture, with sales in second place. Fewer than 3 per cent are in professional, clerical and related types of occupation. Among all types of workers the majority are employers and self-employed. In addition nearly one-third of farmers work on family land. Very few women are actually employed by others as salary and wage earners (See ILO, 1974, pp. 144-145).

Those who are educated and employed work mainly as nurses (71 per cent of the total are female), elementary school teachers (27 per cent female), secondary school teachers (21 per cent female) and typists (44 per cent female). The majority of all these are in government employment. Women's access to wage employment has become more restricted by the lack of vacancies, in addition to their lack of education and training compared to their male counterparts.

2.2 Status of employed women

It has frequently been written and stated with pride that Ghanaian women as workers have equal rights with men. Certainly, in government employment women and men at the same rank have always had the same salaries. Ghana ratified the ILO Equal Remuneration Convention in 1951. Legislation dealing with the legal status of women includes the statute requiring industrial and commercial employers to provide certain minimal benefits to pregnant female employees. However, a study carried out by the NCWD on the conditions of women workers with respect to maternity protection and medical facilities in the collective agreements of the major private and quasi-government establishments found that only 44.7 per cent of agreements are consistent with the standards of labour laws in Ghana. Moreover, data from employment centres for the period April 1971 to December 1975 indicated that employment practices favour males rather than females.

It has been observed that except for a few isolated cases women are mostly engaged in small-scale, low-productivity and low income earning activities, all of which have had little benefit from government extension services or loan schemes (Ewusi, 1982). Furthermore, two studies sponsored by the NCWD have clearly demonstrated the small part women play in crucial decision-making processes at every level. Only 6.4 per cent of members of national-level boards, councils and local councils in the seventies were women (Ameyaw, 1977). This is certainly in contrast to the parallel and complementary roles of females and males in traditional political and military spheres (e.g. Arhin, 1983; Oppong, 1973). Under recent governments, however, the number of women in high office has been small. In addition, an NCWD enquiry showed that only 6 per cent of senior civil service posts were held by women and these were mainly in administrative and relatively more junior positions (Campbell Platt, 1978).

2.3 Wives

(i) Choice of spouse

Although an increasing proportion of modern urban marriages of educated people are the result of personal choice and contact, often arising out of friendships started at school, college or work, or through the introduction of a relative or friend, there continued in the seventies to be considerable acceptance amongst educated young people, both men and women, of the fact that it may sometimes be appropriate for a person's parents to choose a suitable marriage partner. Child-bearing remains a primary goal of the union (e.g. Oppong, 1975). Among the uneducated, marriages continue to be arranged, at least for the young.

Most marriages, even church and ordinance marriages, take place after the performance of customary rites, so that marriages

completely unsanctioned by kin are relatively uncommon; but their consent is often merely an acknowledgement of what has already occurred and especially in situations where the fiancée has already conceived before they are informed, they may scarcely be in a position to withhold consent, even if they disapprove of the match.

Table II.5. Percentage distribution of women aged 15-49 years, by marital status, 1970

Age	Single	Married	Widowed	Divorced or separated	Total
All women 15-49 years	17.4	72.0	2.9	7.7	100
15-19 years	68.3	29.4	0.1	2.2	100
20-24 years	16.0	76.1	0.6	7.3	100
25-29 years	3.5	87.7	1.3	7.5	100
30-34 years	1.4	87.4	2.4	8.9	100
35-39 years	0.9	85.9	4.0	9.2	100
40-44 years	0.6	80.0	7.2	12.2	100
45-49 years	0.5	72.1	13.5	13.9	100

Source. Census Office, Accra: 1971 Census Supplementary Enquiry, cited in Aryee and Gaisie (1979), pp. 10-11.

(ii) Age at marriage

Nearly all women are married for some part of their adult lives. To remain single is to be a deviant in the case of both women and men. Virtually all females are married by the age of 25. Years of school attendance affect marriage age. The median for women with no schooling is 17.2 years compared to 18.0 for those with one to six years of schooling, 19.9 for women with seven to ten years of schooling and 24.6 years for those with 11 or more years of education. There is also a difference between rural, urban and large urban areas, ranging from 17.8 to 19.2. The Mole Dagbani people in the Northern and Upper regions have the lowest marriage age of any ethnic group (17.0 years). The highest median ages at marriage (19.0-19.6) are found among the Greater Accra and Eastern Region and the Ga Adangbe, who mainly live in these two regions (WFS, 1983).

Table II.5 indicates with rising age the increasing proportion of women who are widowed, divorced and separated, so that among women aged 45 and over these constitute more than a

quarter of the female population. This has multiple implications for women's economic, domestic and parental responsibilities and statuses over the life cycle.

(iii) Marriage types

Several types of marriage system exist concurrently in Ghana, including customary unions contracted according to the traditions of each ethnic group which are all potentially polygynous.[3] The incidence of polygyny was not noted to have changed significantly in the 1960-71 period, with 20 per cent of men having two wives and 6 per cent three or more wives, and little difference in these percentages between the urban and rural areas. The 1970 census data showed that a small percentage of these polygynously married wives were educated, as many as 20 per cent had elementary education in urban areas and 1.5 per cent higher levels of education.

In customary marriages the various transactions involved and the outcomes in terms of the rights and duties of spouses with reference to control over children, use of property, claims to residence and sexual rights differ among the various ethnic groups. A noticeable feature of all such customary unions is their tendency to develop gradually over time and their frequently transitional nature. In addition many women are in common law or mutual consent marriages, in which no formal public contract is sealed, either verbally or in writing.

Over 40 per cent of the population say that they are Christian and a minority of these have their marriages blessed in church (a blessing which does not alter the legal status of the parties concerned). The minority of Muslims can also have their marriages registered under the Marriage of Mohamedans Ordinance, in which case up to four wives are legally allowed. There is no limit to the number of wives allowed under customary law.

There is also a Marriage Ordinance which makes marriage legally monogamous, increases the difficulty of obtaining a divorce and secures rights in the husband's property for the widow and children, should he die intestate. This type of marriage contract is only entered by a small percentage of the highly educated elite (5 per cent). In virtually all cases of ordinance marriage both partners are over 21 and in nearly every case they are already married under customary law. Although the majority of spouses of such registered marriages are salaried, educated employees, only a minority are professional men and women or have professional parents.

Data from 1971 showed that in urban areas 71 per cent had only customary marriages, and in rural areas 85 per cent. Muslim marriages included 19 per cent of the urban and 8 per cent of the rural population. Marriages recorded as mutual consent varied from 3 per cent among urban males to 6 per cent among

rural females. Church and Ordinance marriages included 5 per cent of urban and 2 per cent of rural marriages (Ghana, <u>1970 Census Supplementary Enquiry</u>).

In the recent Ghana Fertility Survey (WFS, 1983) carried out in 1979-80 about one-third of married women had a co-wife. Of those under the age of 20, 17 per cent had a co-wife and of those over the age of 35, 42 per cent. (It was not known whether this reflected a life cycle effect or whether it reflected a real decline in polygyny.) Polygyny was much less common among women with 11 or more years of education, reaching 15 per cent. Regional differences were also found to be marked, with around half of the marriages in the north of the country polygynous, and the lowest in the Eastern Region and Greater Accra, with 27-28 per cent.

For over 20 years there have been various abortive attempts to change or streamline the laws relating to polygyny and inheritance (Vellenga, 1983). But these attempts met with little success in the sixties and seventies. Recently the NCWD had a legal committee working on these issues with a view to submitting suggestions of needed reforms to the Government, and some changes in family law have taken place but these occurred after the period when this study was undertaken.

Whereas formerly most cases in the customary courts dealing with marriage were brought by husbands claiming damages from men who had committed adultery with their wives, more recently, at least in southern Akan communities, the claimants have tended to be women suing the fathers of their children for maintenance (e.g. Vellenga, 1977).

(iv) <u>Conjugal roles</u>

In several accounts the typical segregated nature of conjugal role relationships has been described: the frequent separate living arrangements of spouses and the absence of communal property or joint management of resources. These patterns persist even among the urban and highly educated. Pressures preventing the potential development of conjugal jointness, companionship, privacy or intimacy include the persistence of strong sibling solidarity, the influence of in-laws, the co-residence of kin, the prevalence of polygyny and multiple sexual liaisons, and the frequent separation of spouses. All of these aspects of conjugal roles have been described for women and men in salaried employment such as teachers, nurses and clerks (Oppong 1977a, 1985a).

2.4 <u>Mothers</u>

Social and cultural pressures persist in Ghana, as in other West African societies, for child-bearing to continue throughout the potential reproductive span (Ware, 1983). The majority

desire six or more children. Another common feature is for women's domestic, conjugal and maternal role activities and expectations to be closely interwoven with their subsistence production and trading activities. Labour inputs from children are often essential for successful expansion of productive and distributive activities (Okali, 1983; Robertson, 1974).

One-quarter of births occur to women over 35. Reproduction is combined with productive work inside and outside the home. Indeed, Ghanaian women differ from their counterparts in many other cultures in that they aspire to, and for the most part achieve, highly productive economic and prolific reproductive lives. They want large families immediately they marry and they do not intend to stop working and earning or making money to have them, indeed in many cases they are the main sources of material support for their children.

Mothers continue to be awarded higher social prestige than barren or childless women who are still looked upon askance, their situation not infrequently being ascribed to loose living, frequent abortions, witchcraft and the like. The first birth continues to mark the parents' transition to fully mature adult status (Fortes, 1974).

(i) Family size

Ideal family size continues to be large, varying between five and six or more in urban and rural areas. About 60 per cent of women in the Ghana Fertility Survey (WFS, 1983) wanted five or more children and only 6 per cent wanted three or fewer, and there is no evidence of preference for boys. Mean completed family size estimates and total fertility rate calculations for the whole country and major sub-categories such as urban, rural, and so on, vary between six and seven. Like women in the rest of the region, Ghanaian women tend to continue to bear children throughout their reproductive span - from puberty to menopause. The Ghana Fertility Survey (WFS, 1983) showed that the mean number of children born to all women varied by age as shown in table II.6.

Table II.6. Mean number of children ever born, by age group

Current age	15-19	20-24	25-29	30-34	35-39	40-44	45-49
Average live births	0.2	1.4	2.7	4.0	5.4	6.1	6.7

Source. WFS (1983), p. 6.

The completed family size of 6.7 for women 45 and over showed fertility to be high. However, the rate of child-bearing at ages under 25 is relatively moderate for African countries. Nearly 80 per cent of teenagers remain childless. Child-bearing tends to increase sharply in the age group 30-34 and remains high at older ages. By the age of 45-49 nearly a third of women had nine or more births, 70 per cent six or more and only 15 per cent three or fewer. Only 4 per cent had one or no children.

Retrospective estimates for the period 1967-78 indicated that fertility was more or less stable at about seven children per woman up to the mid-1970s, but that some decline took place between 1973 and 1978, and this occurred mainly in the age group 30-39.

Premarital child-bearing in Ghana is estimated to be lower than in some other African countries, being 8 per cent of ever-married women married for five or more years, but is much more common among women marrying at older ages.

There is very little difference in fertility levels by urban or rural residence. Among women with no schooling, urban residents have higher fertility.

The Northern and Greater Accra Regions are among those with the lowest levels of fertility among women married 20 or more years, and education differentials are substantial in all regions, with fertility declining as education rises, especially at the higher levels. Primary education is not necessarily associated with any decline in fertility levels (see table II.7).

Table II.7. Mean number of children ever born to ever-married women, by years since first marriage and level of education

Level of education	Duration since marriage		
	Less than 10	10-19	20+
No schooling	1.70	4.54	6.53
1-6 years	1.69	4.35	6.62
7-10 years	1.58	3.95	5.81
11+ years	1.37	(3.34)	*

* = Less than 20 women.

Source. WFS (1983), p. 9.

Women who have never been married still conceive (table II.8) and women who are economically active still produce children. Economic activity and childbirth continue throughout the life span with the responsibilities of both simultaneously falling most heavily on women in mid-life. After the age of 40, while child-bearing diminishes, economic activity to maintain the children already born reaches its peak.

Table II.8. Average numbers of children born alive by marital status and age group to urban women

Age group	Have no husband				Married
	Never married	Separated	Divorced	Widowed	
15-19	.046	.956	1.122	1.250	.693
20-24	.279	1.500	1.499	1.519	1.650
25-29	.607	2.396	2.572	2.951	2.963
30-34	.843	3.392	3.559	4.359	4.503
35-39	1.103	4.274	4.249	4.941	5.521
40-44	2.313	4.085	4.669	5.594	6.259
45-49	1.000	4.676	4.732	5.401	6.429

Source. Gaisie (1979).

Table II.9. Completed family size of urban, suburban and rural women by employment status

Employment status	Urban	Suburban	Rural	Total
Employee	4.5	4.9	5.3	4.7
Self-employed without employees	6.1	6.5	6.8	6.6
Self-employed with employees	6.5	7.4	7.0	7.1
Unpaid family worker	6.6	7.9	6.9	7.0

Source. Gaisie (1979).

A major feature which most markedly distinguishes between women in different fertility levels is employment status. Female employees have fewer children than their counterparts who are either self-employed with or without employees or unpaid family workers (see table II.9).

(ii) Breastfeeding

Breastfeeding is normally of relatively long duration but has declined in the past two decades especially among urban, employed mothers who had access to infant milk foods imported from abroad. A study in three areas showed that breastfeeding varied between 12 months in Madina, a southern urban area and Essumeja, a mainly Asante area, 17.6 months in Atabu (Ewe) and 21.4 months in northern Dagomba villages (Gaisie, 1981).

Labour laws in Ghana regarding provisions for pregnant and lactating women, though generous by some standards, have been considered grossly inadequate (Pappoe, 1982). Legally the pregnant female worker is allowed six weeks' leave before and six weeks' leave after confinement. A female worker nursing a child is allowed half an hour off twice daily during working hours for nursing. This nursing period ranges from 6 to 12 months. (Some evidence of employers' and managers' negative feelings towards women workers because of frequent leaves of this kind has been noted (Pappoe, 1982; Date-Bah, 1982)).

(iii) Post partum abstinence

There are significant differences in patterns of post partum sexual abstinence among the ethnic groups in the country. Among northern peoples abstinence periods of two to three years are practised. Dagomba newly delivered mothers customarily go to stay with relatives during this period. Survey data from three areas, rural Dagomba and Ewe and a multi-ethnic urban area, have shown considerable ethnic diversity in lengths of abstinence periods (Gaisie, 1981).

These ethnic differences are noted not to be due to age, education, and so on. Such considerable differences in sexual behaviour and consequently child spacing may go a long way to explain the differential fertility of the various ethnic groups (Gaisie, 1981, p. 247). Indeed some view much of the regional variation in fertility in Ghana as being most probably accounted for by differences with respect to breastfeeding and post partum sexual abstinence.

Given the critical nature of post partum abstinence in spacing births and thus lowering potential fertility, shortening of this period may have the effect of increasing the numbers of births, a process which has been in fact observed for some time. The effects of shorter breastfeeding periods upon post partum amenhorrea may also be significant and such a change has been

- 34 -

observed with urbanisation. Presumably also mother's employment outside the home and separation from her infants is an important intervening factor.

(iv) Child-care and its delegation

Extended breastfeeding and carrying infants on the back are typical aspects of customary nursing practice, as is tender care by grandmothers and others, including ritual bathing and ceremonial entry into social life. Mothers involved in traditional forms of work such as farming and trading typically have their infants with them. However, a notable feature of Ghanaian motherhood is the extent to which child-care responsibilities are delegated to non-parental kin and others, thus alleviating the potentially heavy burdens of care which might otherwise need to be borne by the biological mother.

In Ghanaian traditional patterns of child-care, maternal roles are intricately intermeshed in a web of wider social relations defined by rules of kinship and descent (Fortes, 1978; Goody, 1982). Kin play a significant part in child-care and the existence of widespread sharing and delegation of parental activities has been variously documented. However, the extent to which the mother's role is delegated is changing rapidly among migrants, and role strain and conflict have been documented among mothers who try simultaneously to rear several children and hold jobs in the formal employment sector, where strict time and place rules govern the work patterns. Such strain and conflict have been described for teachers and nurses, in particular those who do not have kin on hand to whom to delegate responsibilities (Oppong, 1977a and b) and for factory workers (Date-Bah, 1982).

(v) Maintenance of children

The share of responsibility borne by women for the financial costs of the maintenance and education of their children varies considerably according to the resources, status, values and constraints of the parents and kin involved. Increasingly with migration, urbanisation and unemployment the opportunities for and pressures towards paternal irresponsibility have grown (e.g. Oppong and Bleek, 1982) and complaints of financial neglect of offspring by their fathers have increased. On the other hand, studies of domestic budgeting among the educated have shown sharing of responsibilities by parents. Fathers in some cases actively participate in child-care, as well as playing an important part in bearing educational costs (Oppong, 1982b, 1983, forthcoming).

(vi) Mother/worker roles: Strains and conflicts

As noted above, marked differences in family size exist
between women in different occupational categories. Self-
employed women, in agriculture and trade with employees and
women working in family farms and businesses have the largest
numbers of children. Women employees, especially those in
urban areas, have the least (see table II.7).

There are critical contrasts between women in different
occupations. For some, children constitute an important source of
family labour, without which women or their kin and husbands
would have difficulty in enlarging their farms. For others - the
self-employed - when the income earning takes place in the home,
it does not conflict with child-care. The children may in addition
constitute an important source of labour, as in trading. Among
employees, in contrast, potential role conflict is present once
maternal role substitutes are scarce or expensive. A number of
micro studies have been carried out among traders and farmers
(Okali, 1983; Bleek, 1976a; Church, 1978), among lower-level
professionals such as teachers, nurses and clerks (Oppong,
1985a), factory workers (Date Bah, 1982) and urban dwellers
(Caldwell, 1968; Church, 1982). These help to explain the
differences in fertility between women in different occupational
groups, in terms of child labour inputs on the one hand and
occupational/maternal role conflict on the other. Ethnographic
studies have also helped to throw light upon the activities and
family size patterns of small and selected populations, such as
unmarried women in urban contexts and educated migrants and
non-migrants (e.g. Dinan, 1983). Lack of child-care facilities
and help from kin means that some women, who find employment
and need the income to maintain dependants, may have to neglect
their children in the process.

Women such as nurses, who work away from home for fixed
periods and cannot have their children with them at work, are
noted to undergo constant worry and strain because of lack of
adequate child-care, especially those who are migrants and live
far from kin. Significantly, problems and conflicts associated with
child-rearing appear to be associated with small family size in-
tentions and consistent contraception is associated with innovative
aspects of the conjugal role relationship, including joint knowledge
and decision-making and higher levels of husbands' domestic par-
ticipation (Oppong, forthcoming). There is, however, a lack of
recent in-depth studies or sophisticated survey work focusing
upon the large numbers of women in informal sector employment,
including both sales workers or traders of different kinds and
small-scale manufacturers in both rural and urban areas.

(vii) Birth control

In the Ghana Fertility Survey (WFS, 1983), 68 per cent of
women had heard of one or more methods of contraception. The

best known methods were the pill and abstinence, which were
known by about 46 per cent (see table II.10). In fact,
abstinence was the most commonly used method, having been used
by 25.8 per cent; 10.7 per cent had used the pill and 8.8 per
cent rhythm methods. These three were the most popular,
followed by sterilisation - 7.8 per cent. Thirty-two per cent of
women with large families had used abstinence. Nearly all women
with 11 or more years of education knew some methods of contra-
ception and the proportion was greater for women in urban areas
(78 per cent) than in rural areas (63 per cent). There were also
noted to be great regional differences, with the lowest levels of
knowledge in the Northern and Upper Regions and the highest in
the Greater Accra District and Volta region. Use increases with
levels of education, with 71 per cent of women with 11 or more
years of schooling having used a method at some time.

Table II.10. Percentage of women knowing
 different methods of contra-
 ception

Method	Percentage
Pill	46.6
Abstinence	45.6
IUD	33.4
Condom	30.4
Female sterilisation	29.4
Female scientific	26.1
Injection	22.0
Rhythm	20.6
Withdrawal	18.5
Douche	7.8
Male sterilisation	4.0

Source. WFS (1983), p. 12.

With regard to the desire to stop child-bearing, only 12 per
cent of women in the Ghana Fertility Survey wanted no more.
The percentage increased with age, but even among women aged
45-49 it only reached 38 per cent.

The main traditional method of birth control and maintenance
of maternal and child health, as noted above, has been spacing,
through prolonged breastfeeding and a post partum sexual taboo
promoting abstinence, sometimes associated with spatial separation
of spouses.

(viii) Abortion

In Ghana legal abortion is allowed on broad health grounds but there is considerable evidence for the proliferation of illegal abortions.[4] Indeed one might almost consider that in some circles at least, this is a widely and almost openly used method of fertility regulation.[5] In fact the incidence of illegal abortions is believed to be very high in the expanding urban areas of many African countries.[6]

The extent to which abortion is practised in Ghana will never be fully known, but as medical experts have noted the numbers of such cases treated in hospitals after medical complications occur can serve as a useful indicator of the magnitude of cases and hence of the unmet needs for more widely available and acceptable modes of fertility regulation (Ampofo, n.d. and 1971).

Hospital statistics collected have given figures of as many as 306 abortion cases per 1,000 deliveries at Korle Bu Teaching Hospital, Accra, where from 1969 abortion cases numbered over 3,000 per year. Indeed the number of abortion-related admissions increased by 31 per cent between 1967 and 1976.[7] Ampofo has estimated that at least one in four to one in five pregnancies end in abortion and that the rate is higher in urban than rural areas; the majority of these induced abortions occur without proper medical supervision or care and are carried out by a variety of inadequate techniques.

Several recent ethnographic studies have revealed the extent to which abortion is treated by women as an important means of birth control and a method which some erroneously consider to have fewer side-effects than modern forms of contraception. Women who resort to this practice include the young and old, employed and unemployed, rural and urban (Pappoe, 1982). The informed and wealthy are able to take advantage of modern medical facilities, while the rest use a variety of methods and resort to the assistance of non-medically trained people.

A small-scale study of abortion in one Akan lineage in a rural community by Bleek (1978) revealed that out of 42 women almost half of those under 25 had had an abortion. They tended to resort to the practice at the beginning of their child-bearing career, often while still in school, and the majority also occurred outside marriage. Knowledge of methods to produce abortion were found to be many and widespread (53 were listed) and seven abortionists were known. Bleek's conclusion was that abortion is the most condemned method of birth control but also the most widely used (see also Bleek, 1981).

The use of abortion by African women to postpone the first birth, to space pregnancies and to control completed family size has been documented with evidence from many countries. The rising cost of living and consequent pressures to reduce child-bearing plus lack of family planning knowledge and services have been noted as contributing factors. In addition there is the breakdown of a major form of traditional spacing, post partum abstinence - due to the lack of customary separation of spouses

after birth and decreasing incidence of polygyny. Furthermore, the propensity of urban, educated young women to postpone marriage and child-bearing increases the likelihood of unwanted pregnancies both among schoolgirls and working women. Such a problem has been exacerbated in Ghana by the concentration of the national family planning programme upon the needs of married women to the neglect of the unmarried (Bleek, forthcoming).

2.5 Housekeepers

(i) Residential patterns

Customary residential arrangements after marriage vary. Among the southern ethnic groups, the Akan and Ga, traditional patterns of residence for husbands and wives were separate or apart, with spouses frequently residing with kin rather than wives or husbands and these customary patterns continue to some extent. In addition residential arrangements are likely to alter as pregnancy, childbirth, polygyny, job transfers, and so on, occur. In the whole country about a quarter of rural and two-fifths of urban couples are living apart, spouses living in different houses in the same locality, with alternating residence together and elsewhere or in different localities (Aryee and Gaisie, 1979, p. 20). Some urban split residence may be the result of urban housing or transport problems or job transfer, since many salaried earners are government employees subject to arbitrary movement from one post to another.

In the country as a whole 29 per cent of household heads are accounted to be women, and the majority of separated, divorced and widowed household heads are women, as many women in their later years do not remarry.

Co-residence of non-nuclear kin is common in both urban and rural contexts, the precise categories of kin varying according to ethnicity and socio-economic status. Compounds in rural agricultural contexts are frequently occupied by siblings and offspring; the elderly widowed and divorced usually live with younger siblings or adult children, if not in their own households with junior kin. Given the common practice of fostering as noted above, a large minority of children tend to reside with non-parental kin.

(ii) Domestic activities

Housework - the cleaning, washing and cooking, which in some culture areas has been a full-time occupation for women - is not highly regarded by Ghanaian women. For those living in traditional housing - mud and thatch rooms - a cursory sweep in the mornings may be all that the house itself receives daily. Cooking and laundry are the major tasks and where necessary

water and fuel collection. All of these are delegated where possible to younger household members.

Women's major activities, like those of men, are their productive and income-earning work. Domestic tasks have to be added on to these so the working day tends to be long.

Little systematic work has been done to document women's household time use and activities other than in a general and descriptive way. The few small studies that exist, however, indicate that women work long and hard at their various tasks. Thus a time budget study of 60 women in Osu, Accra, using both interviews and observations to gather data on time spent per day on money-earning activities, home production and personal activities, depicted women with a workload of nearly 10 hours a day, with little help from household members and little time to spend on personal needs. Their recreation consisted mainly of chatting while working and visiting kin (François, 1981). Ardayfio's (1986) study in coastal communities recorded the energy-sapping hours of work every day required to find fuel and water, as well as to prepare meals in a period of serious drought. Some women spent more than 10 hours a day on such activities.

The only women who need to maintain high standards of domestic furnishings, decorations and cleanliness are the few living in bungalows and apartments and many of them, at least in the recent past, have enjoyed the services of domestic helpers including maids and junior relatives.

2.6 Kin roles

A number of now classic and more recent ethnographic studies have described in great detail and depth for different ethnic groups the salience of kinship in all aspects of life: the persistence of kin groups in business enterprises as well as agricultural production; the persistence and solidarity of kin ties in contrast to fragile conjugal bonds; the influence of senior kin in domestic decision-making processes; the importance of descent groups as property owning and managing corporations; the participation and influence of kin in procreation and child rearing. Comparisons between different ethnic groups have shown marked differences but certain pervasive features, such as those enumerated, have also been underlined. Studies of change among the urban educated and migrants have indicated directions and dimensions of change in the midst of continuity: some shifts towards individualism and the dwindling of the rights and duties of kin; some signs for a few of increasing functional closure of the conjugal family in some spheres of activities at least (Oppong, 1982b), but for others increased dependence upon and involvement with kin, as conjugal expectations remain unfulfilled and demands unmet (Dinan, 1983; Oppong and Bleek, 1982).

Thus many women, as sisters, daughters, grand-daughters and nieces, still obtain access to a livelihood through land or

business opportunities, a place to stay in a family home or relatives' house, social prestige through association with names of wealth, power or antiquity, and influence through links to kin with access to jobs, housing or commodities. Any or all of these may be critical for their access to, and maintenance of, certain levels of economic, political or social status.

2.7 Community roles and individualism

In rural and more traditional urban communities the main non-familial sources of pleasure and affiliation are religious activities and groups. Choirs, bible reading sessions and church services provide important socially approved occasions for women to meet each other and men, times when they can leave home in the evening without risk of gossip.

But for the urban woman more liberated from the sanctions of kin and neighbours, other opportunities became available in the sixties and seventies for leisure spending and pleasure. Accra and other urban centres, including Tamale to a limited extent, have discothèques, cinemas, cafés and clubs where women and men of all ages, single and attached, congregate to form and continue liaisons, to drink and gossip and enjoy night life. Dinan (1983) has provided a picture of these opportunities for unmarried educated women in Accra, the kind of life that they lead and the pleasures they can enjoy and the access to extra sources of income they might obtain. In the period under discussion such leisure pursuits were less in evidence than at an earlier time, due to the pressing financial constraints and ensuing material deprivation.

Having outlined the general picture of women's roles in Ghana we next go on to specify the methods used in this study for data collection and analysis, including focused biographies, the way in which the 60 women studied were selected and the ways in which the seven roles framework, briefly described above, was used systematically to collect, analyse and present data on women and their changing roles.

Notes

[1] In 1970 over 70 per cent of salaried and wage earners (in establishments employing more than 10 people) were working for public authorities.

[2] This child labour has been documented in a number of studies including Oppong (1973), Schildkrout (1973) and Robertson (1974). On the problems of documenting women's work in West Africa and elsewhere, see Pittin (1982 and forthcoming) on Nigeria; Anker (1983a and b); Oppong (ed.)(forthcoming).

[3] Polygynous marriages are those in which the husband may have more than one wife. (Polygamy means marriage to more than one spouse. Polyandry means marriage to more than one husband). See Oppong (1985b). No account is taken in this discussion of the changes in marriage and family law occurring in 1985 after this study was completed.

[4] Although the proportion of pregnancies terminated each year by induced abortion throughout the world is not known, it has been estimated that world-wide there are 300 per 1,000 known pregnancies (i.e. live births plus abortions) and that the abortion rate is around 70 per 1,000 women of reproductive age (Tietze, 1981).

[5] Cf. North America in the mid-nineteenth century (Tietze, 1981, p. 21).

[6] Tietze (1981, p. 25) has noted that it is highly improbable that any population has ever attained a low level of fertility without major recourse to abortion either as a primary method of fertility regulation or as a back-up procedure for contraceptive failure.

[7] See Population Reports (Baltimore, Johns Hopkins University Press), Series F, No. 7, July 1978, "Pregnancy termination", table 17, p. F141, and July 1978, table 6, p. F117: "Treatment of spontaneous and induced abortions as proportion of gynaecological services: Operations 1967-1969, Ghana, Korle Bu Hospital".

CHAPTER III

THE METHOD, THE SAMPLE AND THE STUDY

This project set out among other goals to support the contention that knowledge about everyday human interactions and orientations is essential for the building of viable economic and demographic theory. It was clear from the beginning that an important place to study changes in reproductive and productive behaviour and aspirations is the daily living patterns and decisions of people within their domestic contexts. The project was thus initially designed with the understanding that one cannot find out enough about family size and child-bearing solely by asking people direct questions, because questionnaires impose too narrow and rigid a format and contain numerous unstated assumptions. It was rather reasoned at the outset that a broader context of social and family life would need to be observed, documented and understood, before differences in fertility goals and achievements could be comprehended (cf. Cicourel, 1975). Thus a format was developed for obtaining information about people in minimally structured settings, and observing individuals' activities and attitudes in a broad social and family context, before attempting to comprehend differences in fertility goals.

1. The Biographical Approach to the Study of Social Change

The collection of life histories or focused biographies has long been a basic technique of ethnographic data collection. Baba of Karo by M. Smith (1954) provided a pioneering and unique example of what can be done using this kind of approach in an African context. Recently S. Levine (1979) and Shostak (1983) have shown how biographies of African women can give unique insights into social and cultural systems.

The biographical method has, however, in the recent past been relatively neglected, partly because of its difficult and time-consuming procedure. An experienced interviewer takes many hours of patient work to collect an account, in depth, of an individual's life history and to observe sufficient day-to-day activities. Some social scientists are, however, finding it a very rewarding method of approach (e.g. Bertaux (ed.), 1981).

Many of the scholars now working with life histories and biographical data have drawn inspiration from Thomas and Znaniecki's (1918-20) classic study of Polish peasant migrants to America, which was based on the premise that impacts of larger social changes could only really be understood by tracing them through the lives of individuals. Life histories have been viewed

as structured self-images or "identities" in construction. The individual represents those aspects of the past which are relevant to the present, in terms of the intentions by which present actions are oriented (Kohl, 1981, p.65).

A recent important development in the study of the individual and social change has been the study of the life course in historical contexts of cohorts of people in contrasting socio-economic environments, with a focus in some instances upon the individual effects of major economic, political and demographic transitions and transformations such as economic collapse and prosperity (Elder, 1974). Elder (1981) is among those who advocate the value of the life course perspective for bringing historical insights to institutional arrangements, personality and their relations.

More than the survey approach, the collection of focused biographies enables the researcher to examine social relations and interactions, not just isolated social facts or discrete variables and to explore individuals' motives, values, decisions and actions leading to change. Thus Thompson (1981, p. 298) has argued that the nature of social change has often been conceived in terms of male experience and in terms of collective and institutional pressures and groups, but often omitted from accounts have been the cumulative effects of individual pressures for change and it is exactly such data which emerge from life histories - decisions made by individuals to migrate, to change jobs, to save, to marry, to divorce, to give birth, to contracept or not. He argues that the changing patterns of millions of conscious decisions of this kind are as much or probably more important for social change than the acts of politicians (ibid., p. 298).

In illustration he pointed to two of the most dramatic changes in Western Europe and North America in the past 50 or more years - the rise in economic productivity and the reduction in numbers of births, noting that both of these trends still depend to a large extent upon individual decisions of mothers and fathers, women and men and that they remain scarcely understood, unpredictable and uncontrollable. Indeed as he emphasised, the essential mechanisms of two of the most basic forces for social change - change in a society's economy and its population - are very imperfectly understood. Moreover it is his contention that this will remain the case until what is known through studies of abstract economic and demographic models and ideological and collective pressures is put together with the understanding - which can only be gained through life histories - of how such forces interact at the individual level. Such micro-level studies can help to show how all those thousands of small decisions occur, out of which the stuff of social change and history are made. It is thus argued that the life history or focused biography is an essential part of the social facts needed for interpretation of change (Thompson, 1981, p. 299). The roles played by the individual have been forgotten in many current models used by social scientists. They need to be incorporated. Neglect of the

individual parent, both fathers and mothers, has been particularly widespread in studies of differential fertility and the demographic transition, in which the smallest units of analysis have often been models of "households".

1.1 Data collection: Focused interviewing

The main method used for the collection of biographic data was focused interviewing. In most cases the women's answers were left free, through the use of unstructured or semi-structured open-ended questions. Information or opinions freely volunteered are likely to be more genuine than those elicited by direct questions and pre-coded responses. Thus on the specific topics selected, women were encouraged to give retrospective accounts of their past activities, feelings and attitudes and to discuss their current situations as well as expectations for the future. At the same time the interviews ranged widely enough to allow women the chance to report unanticipated items relevant to the enquiry, thus permitting further probing of attitudes to their several life roles.

An interview guide was used, based on the categories of data in the seven roles framework described above, listing the topics to be explored in the course of the interviews. (An elaborated version of this appears in Oppong and Abu, 1985.) This method of data collection thus combined some of the approaches of psychoanalysis, in that histories of women's lives were collected in a series of freely ranging interviews, and the ethnographer's collection of biographies. The method was used as a sociological rather than a psychological tool, however, focusing as it did upon the women as social beings living in particular social and cultural contexts. Women's reactions and adaptations to their particular social milieux, both in the past and in the present, were continually kept in mind.

In order to collect this type of data over extended periods of time, the investigator, Katharine Abu, needed to establish and maintain excellent rapport with each woman. The actual time involved in the interviewing process varied, depending upon the rapport established, the woman's age and complexity of her life events, between a minimum of three or four hours in one case to other instances in which continuing social relations were formed. For in a few cases the interviewer was taken as a confidante and friend by women, who long after the essential interviews were completed continued to supply information on developments in their lives. Moroever, women varied considerably in how forth-coming they were and therefore in the amount of direction required to elicit information. Those who talked freely and at length needed no more than a general question to open a topic or a few specific questions to clarify detail. Those who were, for whatever reason, more reserved needed to be asked more specific questions. The interviewer had to adapt the technique to every interview situation in order to obtain the best possible quality of

information from each woman. As might be expected, women tended to present their lives in a light regarded as flattering to themselves, at times glossing over or distorting the picture of events that they felt were unflattering to them. Often it was possible to deduce that this was being done and to verify from other sources. An account given at a first interview was sometimes revised and presented in greater detail and with more accuracy at a later session, when the woman felt more at ease with the interviewer. Such distortions and changes were themselves informative for the insights that they gave into attitudes. It was useful to know how people wanted others to see them.

Supporting data were also collected from the women's kin, colleagues and neighbours. The contexts of their situations were further documented by genealogical and household census data and participant and non-participant observation.

1.2 Data analysis

A short and relatively simple method for categorising and coding the focused biographical data was designed, both for role activities and expectations of various kinds. In addition a number of indices for documenting and comparing critical role attributes were devised. The latter include role strain, salience, satisfaction, feelings of relative deprivation, conflict and social, economic and political rewards (status benefits). These have been hypothesised in one way or another in various models of change, as being connected with changing fertility desires and achievements. Examples of how this coding was done are given in Oppong and Abu (1985).

Role strain: the extent to which the individual feels unable to cope with the demands of a particular role - in terms of time/energy, financial or material resources needed and inter-personal relations - is estimated and approximately indicated on a continuum from none to a lot. It is used to serve as a potential pointer to desired areas of change.

Role priority or salience: the extent to which a particular role is of high priority to a woman, who stresses its importance, strives to carry out the attached activities and fulfil the expectations of others, as well as enjoying in various ways the benefits accruing from the role. A highly salient role is likely to involve the pursuit and achievement of a woman's major life goals. [1]

Role satisfaction: this is viewed as the extent to which a woman gains a sense of gratification or pleasure from the performance of role activities or enjoyment of attached status rewards. [2]

Role deprivation: the extent to which a woman feels a sense of relative deprivation with regard to her role status benefits - the gap between her expectations of reward (material and non-material) - and the actual outcomes. [3]

Tension and change: an important concern in this study is dynamic aspects of roles - the extent to which individuals are

being constrained or desire to alter their behaviour and expec-
tations attached to different roles and the pressures or incentives
linked to those constraints or desires. Thus for each role an
estimate is made of the extent to which a woman is trying to
exert pressure for change.

Role rewards: as noted above, much ink has been spilt in
the past decade on the subject of women's "status" in relation to
population issues. Here we have carefully separated out the
different potential rewards for each role into two categories: (1)
economic - indicating by numerical codes the extent to which each
role is a source of material rewards; (2) intangible - the extent
to which each role is a source of prestige, deference and in-
fluence, in other words social and political status rewards.

Role conflicts: the extent to which roles appear or are
reported to be in harmony or conflict is also documented, through
scoring the latent or manifest conflict observed between any two
roles. This scoring procedure facilitates the estimation and
comparison of levels of conflict overall for individuals and between
one key role and all others (e.g. parental role, conflict scores
and occupational conflict scores).

2. The Sample

In view of the fact that education, urbanisation and migration
have all been linked to reproductive innovation as discussed
above, it was decided to study urban, educated women in two
towns. These included both women living in their own ethnic
area and women living in a strange ethnic area. The capital city
of Accra and the northern town of Tamale were selected, and
women from the Ga and Dagomba ethnic groups were chosen from
three age groups at different stages of the reproductive span.

The women of each ethnic group in the study are divided
between those currently resident in their home area (Ga women in
Accra and Dagomba women in Tamale) and those who live outside
it (Ga women in Tamale and Dagomba women in the capital).
There are in fact relatively few women in these latter two
categories, especially among the older age groups. They tend to
know each other, to associate and in the case of the older
Dagomba women in Accra to be connected by ties of kinship and
marriage.

Individual women were contacted in a variety of ways.
Several key women to whom the project was explained were instru-
mental in contacting their friends, relatives, colleagues and
acquaintances. Only two women out of those contacted were
reluctant to co-operate. Some were dropped from those selected
because they did not fit the necessary criteria. Women were
purposely chosen by ethnicity, migration status, place of
residence, and age as seen in table III.1.

Table III.1. Categories of women selected

	Accra	Tamale
Locals	15	15
Migrants	15	15

Note. In each category five women were young (18-24 years), five women were in the middle age range (25-34 years) and five women were older (35-50 years).

The women chosen are all educated to the extent that they can express themselves competently in English and have at least a few years of formal schooling. However, their levels of education vary widely, as do those of their husbands, ranging from elementary schooling to university education. Indeed three husbands have never been to school at all.

Table III.2. Educational levels reached by wives and husbands in sample (N=60)

Level	Wives	Husbands
Nil	–	3
Elementary	23	10
Secondary or post-elementary	17	14
Post-secondary training	13	13
University	6	17
Total	60	56

After elementary education pupils can either, if they qualify, go on to secondary school or to some form of career training such as the lower grades of nursing or teaching, or to commercial school to learn typing, book-keeping and related subjects. Training in these same fields and others at a higher level is also available to those who have attained the General Certificate of Education at the Ordinary Level after five years of secondary

school. There is thus a marked divide on the ladder of educational attainment between post-elementary training and post-secondary training. For the purposes of this analysis, we characterise elementary education only as a low level of education, secondary school only or post-elementary training as a medium level, and post-secondary training or university education as a high level.

In selecting women in Accra we were studying the roles and situations of women in the major and largest urban area of the country, the capital, with an old indigenous population core, the Ga, and also an ethnically heterogeneous immigrant population and the largest concentration of government employees, office workers and others in the country. In addition, Accra during the period enjoyed the most modern amenities of any urban area in the country, from medical and family planning facilities to night clubs, hotels, dance halls, restaurants, libraries and educational establishments. In contrast women living in Tamale enjoyed fewer modern amenities. Even electricity and piped water supplies are subject to disruption. The government hospital is relatively new and well equipped, however, and schools are numerous. But places of entertainment are few and the constraints of traditional and Muslim mores have some impact upon the public behaviour of women in Tamale. For instance single young Dagomba women cannot frequent public places with young men without detriment to their reputations and thus opportunities for suitable marriages. In contrast, women in Accra have fewer such constraints on their behaviour, partly because of the greater anonymity.

The practice of wearing the veil for married Muslim women appears to be more related to educational level than area of residence. Those with low levels of education, whether living in Accra or Tamale, were unlikely to go out without the veil. The more educated might go without or wear it round the neck or carried folded under the arm. Personal preference and the husband's attitude are major factors. A few of the exceptionally devout among the highly educated choose to wear the veil, even though their husbands might not insist that they do so. The veil worn by Muslim Dagomba is of fine muslin, lace or chiffon and covers the hair and neck but not the face. Bright colours to match or contrast with the blouse and long skirt or cover cloth commonly worn are chosen, often with silver or gold thread for special occasions. Home consumption of alcohol or locally made beer was enjoyed by a minority of Muslim women, with or without the consent of their husbands.

Since Tamale, being in the far north of the country, was more recently incorporated into the nexus of the market economy and more recently enjoyed the advantages of modern legal, educational and administrative institutions, more individuals have illiterate parents and relatives in subsistence farming, including those of the same generation. At the same time traditional legal practices and political institutions such as chieftancy and beliefs in witches and ancestral power thrive more vigorously.

2.1 The Ga

The city of Accra grew on the land of the Ga people. The Ga are therefore the most urbanised people in Ghana with the highest incidence of inter-ethnic marriage, especially with the neighbouring Akan. The Ga area stretches along the coast for about 30 miles from west of the mouth of the River Densu to the eastern limit at Kpong and extends inland to a maximum of 20 miles along the Akwapim scarp. There are six major Ga coastal towns including Accra and about 200 villages scattered on the Accra plains which are associated with the six coastal towns. All Ga are citizens of these towns.

Living in the capital the Ga have enjoyed several generations of educational opportunities but these have been enjoyed more frequently by men than women, the former becoming clerks and other government workers as well as fishermen and farmers, the latter frequently becoming traders. As entrepreneurs Ga women have earned a reputation for autonomy and independence reflected in domestic organisation as well as trade.

The sample of educated Ga women includes both those from educated middle-class backgrounds and first-generation-educated workers from illiterate homes in the city centre and rural hinterland. Half of the sample was currently residing in Accra and half in Tamale, 400 miles distant from their home area.

(i) Kinship

The kinship system has been characterised as patrilineal or bilateral with emphasis on the patrilineal aspect (Kilson, 1966). The Ga pattern of residence in which men and women customarily live in separate single-sex houses has been described by a number of writers (e.g. Field, 1940; Kilson, 1966). There are men's compounds and women's compounds. In the latter live the children. The nuclear family is thus not traditionally a co-resident unit. However, the members still eat from the same cooking pot; the food is cooked in one house and divided and eaten in different houses. Azu (1974, p. 24) remarked that an effect of this residential pattern is that a father has hardly any contact with his children or control over them in this system, particularly his daughters. Indeed children are frequently reared by kin (Azu, 1974, p. 45).

Residential separation of spouses is also associated with separate control of income and property, social and psychological distance, lack of intimacy and separate inheritance of goods - girls inheriting their mother's property and boys their father's. At the same time, husbands are supposed to contribute to the maintenance of wives and children and to wield authority over them, as well as in their own kin groups. These customary

- 50 -

patterns of conjugal separation were observed to continue in coastal towns in the sixties and seventies (Fitzgerald, 1968; Azu, 1974).

2.2 The Dagomba

The Dagomba are the most urbanised people of northern Ghana. But the north of the country as a whole, as noted above, has a less-developed economic infrastructure, a smaller urban population and fewer educational facilities than the south. The women selected for study are thus almost all in the first generation of their families to be educated and many are the only ones in their sibling groups to have been to school. The Islamic religion has been spreading among the Dagomba for the past 200 years, with the result that aspects of the Dagomba culture have been partly Muslimised. This is in contrast to the Ga, amongst whom the main outside religious influence has been Christian.

In the past, analyses of statistics of fertility from Muslim areas have indicated that Muslim fertility is high and usually higher than that found among neighbouring peoples (Kirk, 1966). This tendency is not, however, observable in Ghana and the Muslimised Dagomba are among the population with more moderate family size achievements.

Table III.3. Husband's educational level in relation to wife

	Husband has less education	Husband has same level of education	Husband has more education	No husband
Ga in Accra	3	4	7	1
Ga in Tamale	0	2	11	2
Dagomba in Tamale	6	4	4	1
Dagomba in Accra	2	2	11	0
Total	11	12	33	4

Tamale, the capital of the northern region and a comparatively large urban centre with over 150,000 population of different ethnic groups, is located in the Dagomba traditional area. There half of the Dagomba biographies were collected. The rest were collected from Accra-dwelling Dagomba women. Being far from Accra and poorly served with urban facilities, Tamale is not an attractive post for southerners and so the Ga encountered there were mostly low-level government employees

with little choice as to where they might work. Thus, on average, they were less educated and privileged than the Accra-based Ga women studied. By contrast, the educated Dagomba women in Accra, at least the older ones, tended to have accompanied fairly highly educated professionally employed husbands to the capital. In contrast, those in Tamale were married to less educated and less mobile men and hence were likely to be more exposed to the pro-natalist norms of the illiterate society. The majority of educated Dagomba women resident in their home area had as much or more education than their husbands, whereas among the rest the majority of women had less education than their husbands (see table III.3).

(i) Descent groups and households: custom

The traditional kinship system is based on groups of kin descended through males and females to a common ancestor (Oppong, 1973) and the basic unit of domestic organisation is the household "yili" living in a single mud-walled compound or house. The customary nucleus of this is an elementary or polygynous family, to which may be attached the descendants of the head's grandfather, that is the head's brothers and cousins and their sisters with their children and grandchildren, and since women live with their husbands, also the head's wives and his sons and brothers' wives. The strong ties daughters and sisters retain with their natal homes returning (to their fathers' and brothers' homes) after childbirth, and the frequency of marital dissolution and widowhood and the common practice of fostering are such that many people are related to household heads through their daughters and sisters, as well as through their brothers and sons. The male head of the household traditionally wields domestic authority in important matters, subject to prior consultation with his senior descent group members, and within the household he delegates authority to his senior wife, who supervises the domestic activities of the women and children. It is the head's duty and pride to satisfy the needs of all his family members within his compound wall.

(ii) Child-rearing

Dagomba customary dogma and continuing practice both clearly demonstrate that in a considerable number of cases it is not the biological parents of a child who are the main socialising agents during its youth. Instead it may be the father's or the mother's sibling or parent or another relative who becomes in a sense the social parent of the child. Both maternal and paternal relatives hold and may exercise certain rights to rear and train a couple's children. These rights and the exercise of them tend to vary according to estate - whether royal or commoner - and professional group membership, and with personal economic,

domestic and other circumstances. The practice of rearing relatives' children may be viewed as a specific mechanism which detaches a child from the parents and attaches it to the members of the wider kinship group. The parents temporarily hand over the responsibility for rearing their child to a relative. The child goes to live with the foster parent to serve and be trained by him or her. Relations with the biological parents are in the meantime not severed.

Dagomba when discussing the rearing of children state that parents never have complete control over their offspring while their senior siblings and parents are alive. Parents are thought to be under the control of their own parents and also under the influence of the heads of their kindred. In fact parents are not thought to be the best or most competent people to bring up their own children and should not keep all of them.

Even while children live in their biological parents' house, other people influence their mode of training, such as by preventing a father from sending his children to school. In the extreme case a father's sibling may come and take a child to train as he wishes or a mother's brother may come to claim a son on pain of death. In addition grandparents hold the power to curse their children if they will not give them some grandchildren to rear and to serve them.

The Dagomba think that "children cannot be taken to the father's side, they are already there" and there is no term for fostering by the paternal relatives, nevertheless it is axiomatic that sons should be given to the fathers' brothers to be educated, while girls should be given to their fathers' sisters for they will be stricter in rearing them and will not spoil them. Thus a child may be given to the paternal uncle or aunt at the age of between 4 and 8 and will stay there until marriage. According to custom, the claims of a father's senior sister to take a daughter could scarcely be denied because of her influential position in the family. At the same time, it is customary for a man to give one of his children to his wife's parents and in actual fact the claims of the mother's side were and still are often recognised and in particular instances backed by powerful supernatural and political sanctions, which may be denied at considerable personal risk.

2.3 Ethnic similarities and contrasts

In summary we may note a number of similarities and contrasts in the two ethnic groups from which the women studied here have been selected. Both the Tamale Dagomba and Accra Ga are to a large extent urban, mobile people, typically with ramifying ties of kinship with rural as well as urban dwellers. Kin ties continue to be the loci of important material and social transactions. Kin groups based on ties of descent through women as well as men continue to be the important and enduring arenas for political, religious and economic activities, many of which are ritualised in public and domestic ceremonies, including the life

events - births, marriages and deaths - of which demographic patterns are formed, and the agricultural celebrations which mark harvests and the availability of food.

In many ways women and men have recognisable equality of responsibilities, resources, access to property, offices and positions of prestige in the community and in the home. At the same time, however, in both areas males have had more access than females to educational opportunities and thus to modern jobs and new offices of political and social prestige. In both areas women as well as men work in agriculture and trade and when the opportunity arises they have also entered the new fields of government employment as clerks, nurses and teachers.

Both family systems are characterised by polygyny, relative frequency of conjugal separation, segregation of the marital relationship and frequent separation of parents and children. Kin ties, especially filial and sibling bonds, are customarily solidary and an important potential source of present help and future security.

In both systems the conjugal family is seldom a functionally individuated unit for purposes of resource production, consumption or management, neither for care nor socialisation of children. One significant contrast, however, is that among the Dagomba the roles of husband and father have a much greater prominence in terms of conjugal and child support and authority than they do among the Ga.

2.4 Mobility and migrant status

Urban Ghanaians, both women and men, are typically highly mobile. Illiterate urban dwellers readily move in search of jobs or travel in the course of trade, but as noted above, education and the search for desirable "white-collar" employment was a great spur to spatial mobility during the sixties and early seventies (Caldwell, 1969). The government is an important employer of people educated to various levels and civil servants have long been accustomed to periodic transfers round the country (Oppong, 1982b). In this study the economic positions and domestic organisation of those residing in their natal areas may be compared with those of the the geographically mobile, a contrast which in earlier Ghanaian studies has been shown relevant to different expectations and activities regarding family size (Oppong, 1985a; forthcoming). The potential effects of such mobility upon fertility decision-making and outcomes may accordingly be examined.

In social contexts within which for generations the lives of individuals have been dominated by localised kin groups and networks, a move away from the locality in which kin are based may involve a potentially radical break with customary pressures to conform, as well as sources of support and advice and models of traditionally valued behaviour. This study was thus designed specifically to explore the potential effects of such a break upon

behaviour and expectations regarding child-bearing and rearing and to see to what extent the geographically mobile may seek to replicate or substitute the conditions for reproduction of their localities of origin or whether they try to innovate, and the extent to which they are successful in either case.

However, migrant/non-migrant can only be arbitrary labels attached to women, according to where they happened to be living at the time of the study. As described above, the larger population from which they were selected is highly mobile. Indeed women interviewed had previously been migrants or many of those living in their home area were potential future migrants. Similarly, many migrants might, a year or two earlier or later, have been encountered in their home area. For instance a Dagomba typist encountered in Accra was found a year later to be staying with her parents in Tamale for a year, to raise her child to walking age before returning to stay with her husband in Accra. Another Dagomba woman interviewed in Accra was subsequently encountered in Tamale, because her husband had decided to allow her and her co-wife to return to their home town where they preferred to live. Movements of this kind detract from the significance of being a "static", "local" or "migrant" member of the population.

Among the 60 women studied there was also enormous variation in the permanence of migratory movements and in the extent to which, once away, they were capable or desirous of maintaining visiting contact with the home area. Again migrants experience varying degrees of isolation in the host communities. Some had easy access to established communities of their own townsfolk or even kin but others were quite isolated in terms of both social contact and access to services.

We have now indicated the techniques used for collecting, coding and analysing the data, the criteria by which the women for in-depth study were purposely selected and the contrasting characteristics of sub-samples of the whole.

In Chapter IV, the role profiles of the 60 women are examined in some detail, with a particular focus upon the apparent impacts of education, migration and opportunities for employment upon the women's roles.

Notes

[1]
R.A. Levine (1978) in discussing the concept of life course has noted that it is the individual's goals rather than roles that organise career activity and an individual's stress upon certain roles may only be comprehensible in terms of career paths towards long-range goals. Describing the case of Gusii of Kenya, for example, he has emphasised how pervasive is procreative achievement as the sine qua non for goal achievement throughout life and in death. On the number of offspring depends building and maintaining a home, the number of descendants, the size of a

funeral. Thus relaxation is only found among the old who have many descendants. As he remarks, evidence of the salience of the fertility goal is provided by the urgency with which individuals pursue it, the personal sacrifices they will undergo and the importance of this pursuit in contrast to others.

[2] Levine (1978) noted in the case of the Gusii that the main source of pleasure is counting progeny on the land. Affliction is caused by any interruption of the sequence of births and family building.

[3] Again as Levine (1978) has noted with regard to Gusii roles and life course goals and the paths forged towards them, the relevant achievements at various stages of the life course are compared consciously or subconsciously with the cultural beliefs and values. The latter provide standards against which the individual may evaluate personal performance. Thus the individual's self-evaluation in relation to age norms and career goals plays an important part in building up the personal sense of worth. At the same time a sense of achievement or deprivation develops according to the relative achievements and rewards observed of significant others, class mates, age mates, neighbours, siblings and others.

CHAPTER IV

SIXTY EDUCATED WOMEN: THEIR SEVEN ROLES

One of the most striking impressions gained from talking with these women, ranging in educational level from elementary school leavers to university graduates, was the clarity of their aims in life and the ease with which they were prepared to express them. This included their fertility goals. They knew what sort of family size they wanted, whether few or many children. In addition they were quite sure about what kinds of marriage and conjugal relationships and career situations they wanted to accompany their child-raising. Most of them were also ready to admit it when they failed to achieve the sort of family situation desired and when they had been compelled to compromise.

In this section evidence is examined regarding each of the women's seven roles starting with occupations and ending with motherhood. In each case associated activities and expectations are described and role orientations assessed in terms of the comparative levels of satisfaction and economic or social status rewards gained from each role, and the relative levels of priority or salience accorded to each.

1. Occupational Role

Acquisition of new skills - literacy, vocational training, professional knowledge - and access to relatively high and secure levels of income apparently enhances women's resources to such an extent that this role is now for many their greatest source of economic and social status, and crucial as a source of support to other roles, including their maternal role. It thus ranks only after parenthood and marriage in priority and after parenthood and kinship as a source of satisfaction (see table IV.1). Occupational activities, not ties of kinship or marriage, are thus increasingly likely to be an educated woman's major source of maintenance and security and satisfaction. At the same time they are, however, a focus of time strain, given the necessity for many to work away from home for varying periods of time and the general impossibility of combining child-care and domestic tasks with occupational activities (see table IV.2).

Table IV.3 shows some of the variations in occupational role attributes among women of the sample, according to ethnicity, migration, social status and age. Occupational satisfaction is greatest for the non-migrants of both ethnic groups. Several factors contribute to this. Absence of kin to care for children can be an impediment to work outside the home. In addition, the

Table IV.1. Role profiles: Priority, satisfaction and status (mean scores)[a]

Role	Priority	Satisfaction	Role rewards	
			Economic	Social
1. Parental	2.9	2.5	0.07	1.8
2. Occupational	2.5	2.4	2.1	2.1
3. Conjugal	2.7	2.3	1.9	1.8
4. Domestic	1.6	1.7	0.05	0.3
5. Kin	2.4	2.5	1.0	1.4
6. Community	1.5	1.9	0.0	0.7
7. Individual	1.9	2.4	0.2	0.7

[a] Role priority was assessed as: low (1); medium (2); high (3).
Role satisfaction was assessed in terms of the satisfaction apparently derived from the performance of each role: very little (1); some (2); quite a lot (3); a lot (4).
Role rewards, material and intangible, were estimated according to the extent that the role was a source of goods/money or prestige/deference/influence: none (0); a little (1); some (2); a lot (3).

home area is often a richer source of the kinds of contacts which facilitate an individual's informal sector activities such as trading, food processing or sewing. A sense of occupational deprivation was most marked among the migrant Ga of all ages. They were in Tamale either because their husbands or fathers had been posted there or they themselves had been posted there irrespective of their own wishes. The north was an unpopular post for Accra people, being smaller, non-industrial and with more limited infrastructure and services.

Here is an example of a Ga woman who found it difficult to keep her business going when she moved to Tamale with her husband, who was transferred there by his employer.

I started baking in 1975 with my elder cousin in Accra. I worked for government as a receptionist in a laundry until I had enough money to build an oven and then I started baking. In those days there was no difficulty in obtaining flour. I baked for three years. When flour became scarce I had a contact so that I still got a

little flour, but when we came to Tamale things didn't move. Dagombas are hard to understand. The Development Corporation helped a bit and formerly I bought some flour on the black market. Now the Government has stopped the market women from selling flour and the Development Corporation doesn't have it any more. For the past six months I have been selling charcoal but I am going to stop because it keeps me tied to the house. I can't get anybody else to do the selling because another person can't judge how much I want to sell for a <u>cedi</u> or five <u>cedis</u>. Rice on the other hand I can sell for a certain amount per margarine tin. We hope to move to Kumasi soon and I shall try for flour there. My mother was a baker so it is in my blood. I've always been interested in it, otherwise I'd have been in government service because I trained at commercial school.

Table IV.2. <u>Role strain, relative deprivation and desire for change (mean scores)</u>[a]

Role	Strain				Relative deprivation	Desire for change
	Overall	Time	Money	Relation-ships		
1. Parental	5.0	1.6	1.9	1.5	1.6	.5
2. Occupational	3.8	1.7	1.0	1.1	1.6	.5
3. Conjugal	4.3	1.2	1.1	2.0	1.9	.5
4. Domestic	5.3	2.0	1.9	1.4	1.5	.3
5. Kin	4	1.1	1.4	1.5	1.2	.06
6. Community	3.3	1.3	1.0	1.0	1.1	.05
7. Individual	4.4	1.4	1.9	1.1	1.3	.1

[a] <u>Role strain</u> was assessed in terms of the extent to which fulfilment of the responsibilities attached constituted a strain in terms of time/energy, money and interpersonal relationships: no strain (1); a little (2); some (3); a lot (4). Overall role strain was indicated by adding the above three scores. <u>Relative deprivation</u> was estimated in terms of the gap perceived between role expectations and reality: none (1); somewhat (2); very much (3). <u>Desire for change</u> was assessed in terms of whether the woman was trying to exert pressure for change: none (0); some (1), a lot (2).

		Mean hours per day worked away from home	Priority of occupational role[a]	Satisfaction from occupational role[a]	Economic status from occupational role[b]	Occupational time strain[b]	Occupational deprivation[b]	Occupational tension and desire for change[c]
Ga (N=30)								
Young (18-24 years)	Static	5.6	2.4	2.4	1.4	1.8	1.6	.2
	Migrant	4.2	2.4	2.0	1.6	1.2	2.0	.8
	Total	4.9	2.4	2.2	1.5	1.5	1.8	.5
Middle age group (25-34 years)	Static	4.0	2.8	2.4	2.4	1.4	1.6	.2
	Migrant	3.2	2.4	2.2	1.6	1.8	2.2	.4
	Total	3.6	2.6	2.3	2.0	1.6	1.9	.3
Older age group (35-50 years)	Static	6.0	2.6	2.4	2.2	2.7	1.6	.6
	Migrant	5.6	2.0	2.4	2.2	1.6	1.8	1.6
	Total	5.7	2.3	2.4	2.2	2.1	1.7	1.1
		4.7	2.4	2.3	1.9	1.7	1.8	.6
Dagomba (N=30)								
Young (18-24 years)	Static	3.6	2.2	2.2	1.2	3.0	1.6	.6
	Migrant	3.6	2.4	2.4	2.0	1.0	1.4	.4
	Total	3.6	2.3	2.3	1.6	1.8	1.5	.5
Middle age group (25-34 years)	Static	5.8	2.6	3.0	2.8	1.6	1.2	.8
	Migrant	5.2	2.6	2.4	2.2	2.8	1.4	1.2
	Total	5.5	2.6	2.7	2.5	2.2	1.3	1.0
Older age group (35-50 years)	Static	6.4	2.6	3.0	2.6	1.0	1.4	.6
	Migrant	5.6	3.0	2.6	2.8	1.4	1.0	.8
	Total	6.0	2.8	2.8	2.7	1.2	1.2	.7
		5.0	2.5	2.6	2.2	1.7	1.3	.7

[a] See table IV.1 for an explanation of the coding.
[b] See table IV.2 for an explanation of the coding.
[c] Tension and desire for change were categorised as: none (0); some (2); a lot (3).

Occupational role priority was highest for the older migrant Dagomba and they also experienced the least sense of occupational deprivation. Four out of five women in this group had high-level jobs in various branches of the public service, and two had lucrative sidelines in private enterprise. The fifth had a middle-level job with foreign travel benefits. The older Dagomba in the home town, however, were in middle or lower level employment and had much lower living standards. The migrants flourished not so much because of being in the capital, but rather their moving to Accra was linked with their already doing well or being somehow advantaged. Three of the Accra group had fathers with at least some education, whereas none of the fathers of the Tamale group had. All but one had married well-educated men, two of whom were southerners, and they had not conceived before marriage. By contrast four out of the five in the Tamale group had conceived before marriage, thereby limiting their marriage options and in three cases cutting short their education. For that generation in particular an unwanted first pregnancy was an obstacle, because safe abortions were not available and training institutions would not accept a student who was a mother.

Economic and status rewards from the occupational role were more often reported by those in polygynous than in monogamous marriages. This is partly accounted for by the tendency for late marrying, high career achieving girls to enter polygynous marriages, a phenomenon which is discussed in detail below. The early marrying, less-educated women in polygynous marriages also tend to be highly work oriented. They know that they cannot depend on their husband for much financial support because he has other wives and children. Also since there may be less emotional satisfaction to be gained from a polygynous than a monogamous marriage, involvement and attention may be focused on other roles such as the occupational and maternal. In contrast, monogamously married women expressed less satisfaction with their occupational role and also reported deriving less economic or social status from it. Such women may benefit more from their husband's economic status than polygynously married women. Those monogamously married to wealthy men derived far more economic status from their husbands than from their own income-earning activities. Also significant is the fact that most of the polygynously married women were non-migrants and therefore benefited in their occupational roles from living in their home area.

The older Dagomba women whose cases were compiled were among the first northern women to receive education. The two cases given below illustrate the way in which choice of marriage partner and the context of the first pregnancy can affect a woman's future occupational options.

In our day in the north very few people went to school and they were boys. One day the colonial authorities informed my grandfather who was a chief, that he should send a girl of about six or seven for the school.

My grandfather asked my grandmother, with whom I was staying, if I could be sent and my father was also consulted and agreed. I was at the time staying with my mother's mother and when it was explained to her that the colonial authorities were troubling my paternal grandfather for a girl she agreed. I did well in school. In those days if you didn't do well you were dropped. Then I went to middle school for four years. I was among the first group of northern girls to sit common entrance and I was the first northerner at my second- ary school in the south. The teachers were helpful and wanted me to go to sixth form but I wanted to go for teacher training. Nowadays most of the post- secondary teacher training students are sixth-form failures and this is affecting the quality of teaching. In my day the best girls went into teaching and nursing - not now. I'm an inspector and I'm not satisfied with the teaching standards. I met my husband when we were in secondary school. We married soon after I started teaching. We were not able to stay together when we were first married because of our jobs. Then he went to university to read economics and then joined the bank. We discussed each other's careers. He was considering going into the army on the pay side but I wasn't keen on the army. He wanted me to go to sixth form and maybe then to university but our first- born was sick and I couldn't trust anyone else to look after him. Later I went for a further certificate in Education, specialising in maths. I spent some time after than as a zonal superintendent of schools and then went to a special maths unit, teaching teachers how to use the new maths textbooks. Nowadays I feel tired and I want to leave the Ministry of Education and go into the food wholesaling business, buying foodstuffs from the north and selling them down south.

This teacher's pride in her work and career is partly due to her having been of the pioneering generation in education and the professions. In her early years as a teacher she enjoyed com- paratively high social status as well as an adequate salary for her job. Only now when the economic and social rewards of her profession have declined does she think of trading instead.

The next case is of a woman from the same social back- ground as the last one, but whose life followed a very different pattern and who had a much less rewarding career.

My father was a messenger in Yendi. All my brothers and sisters went to school except for five of the sisters. We must be 30 or so altogether. We boarded even at primary school in Yendi and then I did middle school at Tamale. Then I was a pupil-teacher for one year, and I became pregnant. In those days if you delivered you

couldn't go to training college, otherwise I would have continued my education. When I couldn't continue my education I went in for sewing, and then in 1960 when I had had three children I joined the social welfare department. I asked my husband about it and he agreed. While I was at the social welfare department I had maternity leave five times. I left social welfare because there was too much walking involved. The conditions and pay at the bank where I now work are very similar. I didn't have any training for the bank work. We count the money and sort it. We are all on yearly contract. They prefer older women like me because we have finished having children.

1.1 Type of work

At the time of the study only three women were not working. They were all housewives, monogamously married, who wanted to work but were prevented from doing so - two by their domestic circumstances and one by her husband who did not want her to work. Those prevented by domestic circumstances were both migrants, one Ga and one Dagomba. They had insufficient help in the house and lacked the means of getting the goods to do their business when they were away from home.

Two women in the study were students, three were skilled or unskilled manual workers, six were in sales and service jobs, 16 were clerical workers, 12 were lower professionals and eight were higher professionals or administrators; six were trading and one was an independent manufacturer. The majority (60 per cent) were working for government institutions. Of the others, one in six was self-employed, two were paid family workers, and the rest were working in private firms.

A paid family worker is described as follows:

Mercy worked in her parents' factory which employed about 20 people. Unlike her sisters she had failed to complete school because of having a baby. The boy she married was not able to support her, so she stayed with her parents working in the factory and doing a lot of domestic chores for which combined activities she was paid a regular wage.

Nearly a third of the women had current or former secondary income-generating activities. Nearly half of those in government employment had such current or former activities. It has long been common for salaried workers to supplement their income with some form of private enterprise. In operating their sidelines the women in our sample ranged from being substantial businesswomen to petty traders. Two owned commercial vehicles and one was a licensed lotto receiver. Sewing and baking were popular income-earning activities because they could be done at home

outside office hours, and many girls with a medium or high level of education had also learned baking or sewing skills from a kinswoman.

Subsidiary activities were often in some way connected to the formal workplace. Schoolteachers may sell sweets or snacks· to the children, or nurses sell toiletries and baby care items to patients. One teacher who had a freezer in her school campus accommodation sold iced water to pupils.

With the declining availability of manufactured goods and ingredients such as flour and margarine for baking, opportunities for subsidiary income-generating activities are narrowing, and many women have been obliged to cease business or to shift into more traditional and lower-status ways of earning money. A clerk who had formerly been selling china dishes now sold dried fish. She travelled on slow, crowded lorries with her baskets to buy fish in Accra and bring it to sell in Tamale. She regularly took a day off work in order to have a long enough "weekend" in which to make the round trip. Most of her colleagues in fish-trading were illiterate. A few of the Dagomba based in Tamale farmed a few acres of cereals or beans or raised livestock.

Tamale has recently enjoyed a boom in commercial mechanised agriculture, notably rice growing. A lot of men in formal employment have become successful part-time farmers, hiring machinery and labourers to work on their farms, but very few women have taken up commercial farming and they have done it on a much smaller scale than the men.

Having a private income-generating sideline in addition to formal employment was most common with the women in the middle and older age groups, and with the polygynously married, widowed and divorced. Fewer of the younger women were in formal employment, and as yet they had fewer children to support and educate and less need to seek additional employment. Most of the young received some economic support from parents, husbands or boyfriends.

1.2 Hours spent at work outside the home

Hours of employment or income-earning activity spent outside the home ranged from 0 to 8 hours per day. The mean was 4.8 hours. More than half worked 6 or more hours outside the home (see table IV.3). The ethnic differences in hours spent outside the home were negligible, but there were marked differences by age, however, with the oldest women working the longest hours away from home. This is related to the fact that the majority of the older women were salary earners with fixed hours of work outside the home, as compared with less than half of the younger group.

Women in their home towns worked longer hours away from home than migrants, and there were also differences according to marital status. These findings are linked in that (as noted earlier) most of the polygynously married were also staying in

their home area. Thus ten of the 28 monogamously married women compared with only three out of the 32 of other marital status worked as little as 0-2 hours daily outside the home. The following excerpt is from the account of a monogamously married Ga woman living in Tamale whose income-earning activities took place in the home:

> I went to commercial school and then worked as a typist, but the boss was a bad man (sexual harassment) so I resigned. I then started baking. One of my uncle's wives taught me baking. I used to sell rock buns and meat pies in front of the house. After I married I did the same in Tamale at first, but it's a while since I had flour... I will start baking kenkey [corn dough balls] if I can't get flour. Frying yam or plantain is too costly because of the oil. In Tamale if you can make good kenkey you will get customers.

This woman did not utilise her typing skills but chose an activity which she could do at home, at first because of sexual harassment in the office, and later so that she could harmonise income-earning with child-care and domestic tasks. Her plan to shift to making kenkey is another example of the narrowing scope of occupational opportunities pushing women into traditional and conventionally lower-status occupations. This woman's kenkey-making skill was an asset in Tamale where Ga kenkey is popular and there are relatively few producing it.

1.3 Strain and deprivation

More than half (32) of the women felt no strain in fulfilling their occupational role in terms of time, though a small minority (five) did experience a lot of time strain. Mean scores of such strain showed no consistent differences by ethnicity or age. The categories with the highest scores were the young Dagomba women in their home town (3.0), the migrant middle age group, Dagomba (2.8) and the static older Ga women (2.7).

The following excerpt comes from the case study of a Dagomba secretary working in Accra. Although she enjoys her work it does not overlap in activity or location with any of her other roles and so there is some time strain, to the extent that she has been obliged to change jobs.

> I worked for the ministry for two months but I found it too demanding on my time because of household re- sponsibilities. My junior sister is now an apprentice so she gives less help with the housework. My husband fetches our son from nursery school at lunch time and leaves him with neighbours until I get back from work... Now I work for a foreign firm of engineering

- 65 -

consultants. I like secretarial work but in future I
would like to do something by myself.

The majority of women experienced strain, regarding the low
level of their incomes in relation to rising costs of living. The
older ones described how they used to be able to save regularly
out of their salaries and now they cannot.
Several women had a sense of occupational deprivation
regarding slowness or unfairness in promotions. This was a
common complaint by teachers and also those working for the Post
and Telecommunications (P&T). A worker describes her career
and her dissatisfaction with it.

I joined the P&T in 1951 when I was 16 years old. One
of my aunts was there. I was attracted by seeing
people sitting behind the switchboard and with head-
phones. I was an operator for a year and then a
telephonist. In 1963 I became a supervisor; . I was
posted from Nsawam to Kumasi, back to Nsawam and
then to Tamale. In 1978 I was made a telephone ex-
change superintendent. Our promotions are very
slow. When I compare with friends who are teachers
or nurses I see that they have got more promotions and
are big people now. We older ones choose to stay in
the work because we have already put so much time in
it and waited long for our promotions that it would be a
waste to leave. The younger ones these days have
been resigning to go to the banks etc. where the pay
and conditions are better.

Teachers also complain that they have insufficient opportunity for
promotion, or that promotions are unfair because those who take
time to go on further courses come back to find their colleagues
who did not go on courses are getting promoted at the same rate.
Extreme occupational deprivation is experienced by a few
monogamously married women who are unable to work, either
because their husbands do not allow it, or because domestic
pressures make it too difficult. Only one of the older women in
the sample was a full-time housewife, and her sense of deprivation
seemed to be as great as if she had been unable to have children.
She felt an incomplete person, even though her husband's income
was sufficient to provide well for her and the children and she
enjoyed one of the highest living standards of all the women in
the sample. She described how she had tried to start earning an
income.

At one stage I took a catering course and although I
couldn't attend quite regularly I learned a lot. When
my husband travelled abroad for six months I took a
few catering jobs, making snacks for functions and I
earned a few cedis. When my husband returned he
said I should stop. He didn't want me to neglect the

house and children. I tried to explain my ideas to him but he didn't agree so I accepted what he said... The doctor advised me to join societies to get out of the house because of migraines. Playing golf twice a week helps. They have been reducing my handicap, but I don't really care about it.

1.4 Desire for change

A number of women expressed a desire for change in their working conditions or type of work. Twenty per cent were keen to get more qualifications; 15 per cent wanted to advance within their current jobs; 13 per cent (mainly government employees) wanted to switch to the informal sector, and 12 per cent (mainly government employees) wanted an additional means of income earning; 18 per cent (most of the self-employed) were interested in diversification and expansion of their work.

The fact that so many were keen to get further qualifications reflects the fact that if she has the co-operation of her husband or kin or both, a Ghanaian woman with elementary education can embark on further education or professional training courses at any stage of her child-bearing and marital career. Those in the lower grades of nursing and teaching were the ones most interested in improving their qualifications. A few women studied achieved quite high levels of education and employment, despite inauspicious beginnings, including unwanted early first pregnancies and marriage to unhelpful men. Here is an example of one.

I already have middle form 4. I started secondary school after my first child was born but I had to stop because of financial difficulties. I didn't even complete one year. There was a man at the barracks where my father was who helped me. I was very free with this man's wife and I helped her in the house. They were Ga. The man decided to send me to secondary school but when he left for abroad, my education stopped. My father didn't want to educate boys, let alone girls. The second time I became pregnant my parents were not annoyed because they knew the man and he married me. The second child, Memounatu, is with her father. She was 3 years when I left her with her father and my two rivals (co-wives). He said I should be a housewife but I didn't agree. So I left him to go to sewing school... He is quite well off but illiterate. I was the only educated wife and I didn't like it. The other wives felt that I collected his money to buy clothes. The relatives also thought that I looked down on the illiterates... My senior brother advised me on nursing. He made a number of suggestions. I saw that nursing was a professional work with useful skills, and later I

also found that I enjoyed it... My brother sent for the application forms and gave me the uniforms and other things that I needed. The community health nursing course is two years and I have just finished it. Soon I will be doing GCE (General Certificate of Education) in evening classes so that I can go for SRN (State Registered Nurse). My parents still insist I should go back to my old husband but I won't... If I marry I cannot continue training so I don't want to marry again. When my children are older they will come to me. In GCE I have registered to do health science, commerce, economics, English and West African history.

The declining real earnings of those in formal sector employment is reflected in the desire of many of them (15 out of 40) to either take on a private enterprise sideline or to shift full-time into private enterprise.

2. The Domestic Group: Living Arrangements.

Accommodation varied from rooms in poor-quality traditional compounds of swish and thatch or Accra slums of corrugated iron and plywood, to private well-appointed houses in suburban neighbourhoods. The majority had the use of a range of modern conveniences such as electricity, piped water, refrigerators and cooling fans, and half the homes had one or two cars.

The composition of households varied and also changed over time. Fewer than half always had their husbands in residence. In one in five cases he was sometimes present and in the same proportion of cases he was scarcely there at all.

There were co-resident kin in about a third of households and in one in five, co-resident in-laws. Nearly a third had one or more children other than their own living with them (the mean was 1.2 children and the range 0-7).

Conjugal residence patterns differed significantly according to migration and ethnicity. Exactly half of the currently married Ga resided mainly apart from their husbands, compared with less than a third of the Dagomba. This is despite the fact that the Dagomba in the sample have twice as many polygynous marriages as the Ga. With both the Dagomba and the Ga joint residence of spouses was associated with migration. All the migrant, married Dagomba except one student and two-thirds of the migrant Ga lived with their husbands. This is linked to the fact that, as noted earlier, the majority of monogamous marriages were among migrants.

The separate residence of spouses is traditional with the urban Ga (as noted above), but with educated people separate residence is now mostly limited to polygynous marriages, and a few of the younger married people who have not yet been able to establish conjugal co-residence. Among the Dagomba women who traditionally reside with their husbands, except for traditional

periods of post-natal leave, the educated polygynous couples now often reside apart. Some women, especially the Ga, reported spending years in different towns from their husbands because the two of them had not been able to get job postings in the same area. The refusal of many wives to accompany their husbands on transfers to areas where their own careers would suffer highlights the importance of the occupational role to women. The expectation that marriage should survive such lengthy separation of the spouses also attests to the relatively low priority given to the companionate aspect of marriage and one might suppose a low level of emotional and sexual solidarity and fidelity. At times, however, the difficulties arising when the partners live in different towns have caused the breakdown of the marriage. Three of the older migrant Ga in the study were affected in this way.

2.1 Sources and type of housing

Own or husband's level of education had the greatest impact on house type and living standards for the migrant Ga. Tamale being well provided with accommodation for public employees, most of them rented accommodation which was allocated according to job status. By contrast, only two of the Ga in Accra lived in housing provided through a job in the public service. The rest lived in houses owned by kin husbands or themselves (nine) or in privately rented accommodation (four). The quality of the accommodation and the living standards of the Ga in Accra varied enormously and according to complex factors. Husband's education level or wealth were only relevant to the minority who lived with a husband or whose accommodation was provided by husband or boyfriend. Those who lived with husbands tended to be better housed than those who did not. For the rest, the wealth of kin, and quality of housing that they owned was the most important factor. The lowest standard of living and of accommodation among the Ga women in Accra was that of a young widowed clerical worker from a poor rural Ga background. She lived in an illicit new settlement with an inadequate water supply on the outskirts of the city.

Of the Dagomba living in Tamale, the most highly educated women were in accommodation provided through their own jobs as teachers, nurses or in other branches of the public service. Several of them were better accommodated than their less educated husbands. Those with a lower level of education depended on husbands and kin to provide housing; only one in the older group had been able to build her own house. A few with a little education and wealthy but illiterate husbands or fathers were quite well housed, but a few of the non-married with poor kin lived in quite decrepit family compounds with few amenities. Of the migrant Dagomba, the majority were with their husbands and the type of accommodation varied according to the husband's job level. Of the unmarried, most were attached to kin and their

living standards varied accordingly. One of the unmarried and one divorced woman who rented rooms were very poorly housed.

Quality of accommodation and other aspects of living standards such as food and clothing do not always go together. For instance the wife of a civil servant in a spacious bungalow with good amenities might have less to spend on food and clothing than the trading wife of a butcher living in cramped city centre quarters.

2.2 Domestic groups and household help

The nature of the domestic role of the women varied according to the composition of the domestic group and their stage in life. Thus we see marked differences in domestic roles according to age group.

Several of the younger women lived with parents or other senior kin, and irrespective of marital or maternal status occupied a junior role in the home, such that their domestic activities and responsibilities were defined for them by others. The extent of their domestic involvement varied greatly according to the alternative domestic labour resources available in the home. One young clerical worker lived with her parents and was the eldest of eight children. She scarcely had any free time, and when the piped water to the house was off, which was often, her day began at four in the morning with several trips to fetch water. By contrast, a young Dagomba nurse lived in her mother's house where there were several under-employed, less-educated female kin who did all the domestic work and took care of her child.

Those most in need of help were the ones in the middle age group living on their own or with husbands, and whose children were not yet sufficiently grown to take on many domestic responsibilities. The Dagomba tended to make more use of kin, and the Ga to hire maids. The Ga in Accra of middle age depended more than any other group on hired domestic help. The Ga community as a whole, having had much more education than the Dagomba, cannot generally get young kin to help, without incurring the obligation to send them to school. Schoolchildren and students can do many domestic chores but cannot stay in the house during working hours, for instance, to look after young children. Thus the educated Ga women in Accra often hire maids. Many of the Dagomba, in contrast, still use the domestic services of young female kin who will never go to school.

The migrant Ga were in the smallest domestic groups and had the least domestic help. Kin were not anxious to join them in Tamale, and as was noted in the section on occupations, several mothers of young children among the migrant Ga had curtailed their activities outside the home.

The older women in the sample, both Ga and Dagomba, had ceased hiring maids and managed with the help of their children

or junior kin. It was those in the older age groups who most often had junior kin or husband's kin of post-elementary school stage living with them, because they had the financial means to maintain them and the authority to train them.

2.3 Dissatisfaction with domestic arrangements

One in three of the women expressed dissatisfaction with their residential arrangements. Some wanted their husbands to live with them all of the time or more of the time. Many were unhappy living with in-laws. In urban Ghana relationships between a wife and her husband's juvenile co-resident kin are notoriously difficult. Young women living with senior kin often wished to be independent.

Hardly any women perceived the domestic role as a source of economic or social status, or viewed it as a high priority or as a source of satisfaction. Indeed it was perceived as the least satisfying role and had next to the lowest level of priority (see table IV.1).

The Ga more often than the Dagomba expressed a sense of dissatisfaction and a desire to change their domestic arrangements. A third expressed a lack of time and money to fulfil their domestic responsibilities.

3. Kinship

Nearly all the Dagomba and the majority of the Ga come from polygynous family backgrounds. None of the mothers of the Dagomba women, and less than a third of the Ga women's mothers, went to school. The women generally came from large families with an average of five brothers and sisters from the same mother and father.

Fewer than a third of the women in the sample were raised mainly by both their own parents. For half of all the women and the majority of the Dagomba, fathers' wives, often several of them, played an important part in their upbringing.

I grew up in my father's house. My mother left him when I was about 4 and I didn't see her again until I was 14. One of my stepmothers looked after me until I was about 10 when she too left my father. By then I was able to look after myself and was not in the particular care of any of my father's wives. The emotional effect of the separation from my mother was that I became more attached to my stepmother than to her.

Even amongst those Ga who reported that they were mainly raised by both parents, very few actually lived with both parents all the time, partly because of the Ga custom of duolocal

residence. Those who had spent most time with both parents were the young migrant Ga who were in Tamale with their parents and had followed their geographically mobile fathers wherever they had been posted.

Now in adulthood the majority find the kin role an important source of satisfaction, according it a relatively high level of priority in their lives, especially the Dagomba women. For some it is an important source of social and economic status. At the same time many have one or more relatives dependent on them, a pattern which is even more common among the Dagomba than the Ga. Most dependent kin are either juveniles or very old people. The entire financial maintenance of an old person is usually shared between offspring or kin, but when a person takes on a young dependent he or she usually has complete responsibility for maintenance. Dagomba, especially those in Tamale near kin, and those in the older age group expressed more strain than the rest in coping with the financial demands of relatives. A Dagomba woman described how she became the guardian of a half-sister.

> My father's child was given to me when she was 1 year old. Her mother left my father when he took a third wife. She had never liked us and maltreated my father's children as well as her co-wives. It was a pleasure for me to take the child because my father's wives were not prepared to look after her.

(For a fuller discussion of child-fostering by kin see pp. 80ff.)

The migrant Ga were the group deriving least satisfaction and according lowest priority to kin roles. The Ga in Accra by contrast were in a position to spend a lot of time with kin and enjoy access to family housing and other material benefits (see section on sources and type of housing, above). A few of the Ga women in Accra belonged to large, formal family organisations which have subscribing members and periodic meetings and concern themselves with such matters as disbursing incomes from inherited property to contribute towards the education of some of the younger family members whose parents cannot meet all the expenses of educating them.

Dagomba gain particular satisfaction from kin ties in the strange environment of Accra. Much social enjoyment is derived from receiving visiting kin from the north and some regularly receive foodstuffs from their home-based kin.

3.1 Kinship and education levels

In the case of the Ga there was clear evidence of women with a high level of education being the daughters of highly educated fathers. Four of the six highly educated Ga women had highly educated fathers. All had grown up in close proximity to a parent who had a high or medium level of education and who

supported and encouraged them. There were two daughters of highly educated men who had only achieved a medium level of education and they had both lost the support of their fathers, one through death and one through parents' divorce. The highly educated Ga women also came from smaller than average paternal sibling groups (mean 7.5 as opposed to 10.8).

The nine highly educated Dagomba women were the daughters of illiterate fathers. As education is a relatively recent introduction in the Dagomba area, parental levels of education did not yet have a very marked impact on the education levels of the women studied.

4. Community Participation and Individual Pursuits

Women seldom expressed much interest in wider socio-economic processes beyond the immediate impacts that these had on their own personal lives in the form of rising prices and shortages of commodities including soap, sugar and fuel. Most women were concerned with their individual coping strategies; how to survive and maintain their children through obtaining consumer goods through their husbands, kin and workplaces. The majority felt themselves to be on the losing end in the current economic system.

The community role was found to be of low priority for most of the women and not an important source of satisfaction. Most community activity by the women was in connection with a Christian church. Most of the active Christians were Ga, and they included women of all levels of education and all ages from wealthy and from poor family backgrounds. Choirs, women's groups and Sunday-school teaching were popular church-related activities. The Muslim religion featured more in women's roles as individuals or wives than as community members. The only organised religious activities which were available to Muslim women were in educational institutions. Several of the more highly educated Dagomba had been active in student Muslim organisations, and they complained that outside the student context there were no social activities for Muslim women. Four of the highly educated Dagomba women had become Christian, including three who had married southerners. For the Dagomba, unlike the Ga, organised religious activities were confined to the highly educated. Non-religious organised community activities were popular only with the highly educated. These included school associations for former students, professional associations and quasi-political ethnic associations. These organisations were equally popular with the highly educated Dagomba and Ga.

In fact, however, apart from religious organisations women have relatively little scope for community participation. For one thing, they have very little time. For another, they had lived through a period when national party politics had been banned for much of the time and at the local level traditional political activity, while lively, particularly among the Dagomba, is mainly a

men's affair. Even Dagomba women of royal descent included in the study remained politically passive. They did not discuss local palace politics as their brothers did.

Pursuit of individual enjoyment, leisure activities and time spent with non-kin friends are slightly more important to the young, to migrants as a whole, and to the Ga than to others. A few expressed more satisfaction with such activities and several showed evidence of feelings of relative deprivation. The majority of migrant women compared with only six in the home areas enjoyed social benefits from their individual activities. Three of the highly educated Ga, one young and two older played a sport. Three young women with a low level of education living near the city centre in Accra used to go to the cinema. Altogether public entertainments and leisure facilities, even in Accra, played a small part in women's leisure activities.

The most common form of social and leisure activity for the middle-aged and older women involved the festivities surrounding birth, marriage and death. Both Ga and Dagomba have big parties in connection with the naming of babies; the Dagomba celebrate weddings much more than the Ga and the Ga do much more in connection with funerals than the Dagomba. These events include friends and colleagues as well as kin. The scale of festivities depends on wealth rather than education. A lot of alcohol is consumed at the Ga events and none at the Dagomba events.

Informal home entertaining and visiting was common among women in the middle and older age groups, mainly living in Accra with highly educated husbands. Women complained, however, that the scale and frequency of such entertaining had been reduced considerably in recent years due to non-availability of bottled drinks and luxury foods.

Home-town dwellers were much better placed than migrants to participate in naming ceremonies, weddings and funerals. Their family funerals were nothing but an expense for the Ga in Tamale. They were expected to make donations to the funeral expenses but were not able to participate socially. Similarly the less educated Dagomba married women in Accra felt deprived of social activities. Television in the home and a little social visiting with friends and kin scattered over the big city could not make up for the social life of the smaller home town where kin and friends provided a continual round of weddings and outdoor activities, as well as usual social interaction with a wide range of acquaintances every time they went to market.

5. Husbands and Wives

The age at first marriage for women in the study was between 14 and 31 (mean 22 years, median 21 years). Only three women were 28 or more when they married. Twenty-five of the women had married at the age of 20 or younger. The one who had married at 14 had been married against her will and had been

forced to leave school. After having three children she ran away and managed to complete her education. Most marriages were conducted according to ethnic customary rites, or Muslim or Christian tradition. Only 12 per cent of marriages were registered under the ordinance which gives legal protection to the monogamous state. A quarter of marriages of the Ga and half of the marriages of the Dagomba were polygynous. In addition, five of the younger Dagomba and two of the younger Ga were in marriages that looked potentially polygynous. The husbands of these women came mainly from illiterate farming families of the same or related or neighbouring ethnic groups. The majority were in the higher or lower professional occupational categories. The rest were skilled or unskilled workers, clerks, farmers, artisans and traders. Only one was unemployed. Husbands had an average of two children by other wives (range 1-10).

Whether a marriage is monogamous or polygynous is, for the women themselves, its chief distinguishing feature. The existence of co-wives is seen as diminishing the status of any one wife in terms of economic and social rewards, and emotional satisfaction. The benefits felt to accrue from polygyny are mainly in the domestic sphere. The burden of cooking and laundering may be divided. Sometimes the presence of co-wives enables a wife to spend more time on her occupational activities. However, the disadvantages of polygyny clearly outweigh the advantages in the eyes of the women. One of the highly educated, late-marrying polgynous wives commented:

> There are some things about polgyny that are hard.
> You would like the man to be always with you. There
> are things I can't do, like go anywhere with him any
> time. There are a few advantages, for instance I cook
> for him rarely. I don't have to wash his clothes either.
> But the disadvantages are more.

In a society where marriage is a basic status requirement for women, polygyny does make it possible for the infertile and sub-fertile to remain married while her co-wives have children. The institution of polygyny is also appreciated by divorced women who want to re-marry and cannot always find an unattached man whom they want to marry. Several of the women in this study had become second wives in cases where the first wife was infertile. In one case the second wife never went to the man's house or let her children go there because she did not want to upset the senior wife whom she referred to as his "lawful" wife.

The most highly educated exhibited the highest incidence of polygynous marriage (eight out of 18 married). This may seem anomalous, since polygyny generally has a negative association with education, but the focused biographies showed that a high level of education, as opposed to a medium level, combined with

advanced age for first marriage, can narrow a woman's options, forcing her to accept a polgynous marriage. The following case is such an example.

Saadatu, a Dagomba bursar of a large secondary school accommodated in a spacious bungalow and with a new car purchased through a civil service loan, did not get married until she had completed her education and by then she was nearly 30. The man she married, a fellow graduate, already had one wife, and four years after marrying Saadatu he took a third one. Marriage is a problem to her because having married late she was not able to get a marriage appropriate to her socio-economic status or satisfactory to her emotionally. Her feelings about marriage altogether are bitter and cynical.

> I don't see the need for marriage. You can have children and company without. If you examine the trend of events, marriage disorganises people. It has brought more hardship to people. Looking at it traditionally, if you want to be respected you have to do it. The companionship you get from a man is reduced drastically when you marry. Marrying for company is out. Most women would be happier letting men pay for their children and having company from men as they chose.

Her high level of education and her high job status have given Saadatu a sense of her own worth which make her polygynous marriage unsatisfactory to her. In her mind, childbearing and marriage are separable and given the nature of marriage in her culture she would be happier if she could have the former without the latter.

5.1 Conjugal relationships

Conjugal relationships were typically segregated in each sphere of behaviour (cf. Oppong, 1982b; Abu, 1983 on the Akan). In domestic budgeting only six couples pool their incomes. In the remaining cases there were varying degrees of co-operation and conflict in the management of resources separately earned. For example a graduate civil servant in a polygynous marriage said:

> I provide one-quarter of the food money, but when he is hard up I have to provide more. I have to take into account his financial status. If his financial situation improves I'll ask for more. I was self-sufficient before we married and perhaps he is taking advantage of that. We do discuss finances and there is some conflict but I don't like money quarrels so I just forget it. It is the traditional obligation of the man to make basic provision

for the family. Any modification of that is disadvantageous to the woman.

Those couples who pooled their incomes were nearly all Ga and unusually active Christians. In some marriages there was no co-operation at all about management of resources, the man using his own discretion without reference to the wife in deciding how much to contribute to the maintenance of home, wife and children.
Only a minority claimed or were observed to have joint leisure pursuits - twice as many Ga as Dagomba - and the majority said that their husbands never took part in any child-care or domestic tasks. The minority of husbands who did participate in child-care and domestic tasks were overwhelmingly Ga, monogamous and Christian. Shared leisure pursuits of an organised kind were also usually connected with a Christian church.
Most women perceived marriage as very important for a woman's economic status and quite important for her personal happiness and companionship, ranking it the second most important role after motherhood (see table IV.1). The reality of their lives, however, was that fewer than half of those who had ever been married derived much economic or social status from their roles as wives in comparison to their occupational roles. Only ten wives were dependent upon their husbands for maintenance and few were noted to reach high levels of marital satisfaction (even fewer Dagomba (two) than Ga (seven)).
Less personal satisfaction was gained from marriage than from work, parenthood or kinship (see table IV.1). Many experienced strained relationships within marriage, especially the Dagomba women and the middle-aged women in particular. Indeed the conjugal role was reported as being a far greater source of interpersonal strain than any other role (table IV.2). Furthermore, many felt deprived in their conjugal roles either because they had never been able to attract the kind of husband or achieve the marriage type that they wanted, or because of divorce or an unhappy current marriage. Thus the conjugal role was also the focus of the greatest sense of role deprivation. Marriage had not lived up to most women's expectations (see table IV.2).
Companionship is desired by educated wives more often than it is achieved, but on the whole material maintenance is valued more than companionship. An analysis of the statements made by women in the focused biographies shows more of them giving a high priority to economic maintenance (53) than to companionship in marriage (19).
Marriage and procreation are intimately bound together in the consciousness of the women interviewed. Frequently they said that the whole point of marriage is to have children and for the man to maintain the children. Thus marriage is frequently seen as not only supportive of procreation but secondary to it.

You marry to have children and to have someone to take care of you (financially). Love also counts.

> A happy marriage is when you have children and you can take care of them.

The following quotation is from an exceptional middle-aged Ga woman very satisfied with her monogamous marriage. She considers herself to be unusually fortunate. Her husband is remarkably home and church oriented.

> With Ghanaians the relatives of the man feel that it is very necessary to have a child when you marry. If after one or two years you have no child the relatives will tell him to get another woman. Most of us believe that when you marry you should be pregnant but I don't believe in that. Before we married we never knew ourselves and after marriage by God's grace we started having children. We had decided to have two, but when I got pregnant the third time I had to deliver because my husband doesn't believe in abortion. It is better to marry early and have your children early and then rest. If I had married early I would have stopped child-bearing by 35. My husband is the type who doesn't go out unless I go with him. After work he goes to choir practice or works in the garden, plays with the children. He is a different type. I always thank God for having such a husband. He gives the children a lot of attention in the evenings when I am too busy cooking or too tired.

6. Motherhood

6.1 Maternal rewards

The majority of women gave their maternal roles a higher priority than any other (see table IV.1). As a source of personal satisfaction the maternal role shared top position with the kin role. Motherhood is also perceived as an important source of social status, especially by older women, though not as much as the occupational role.[1] Hardly any of the women yet gain any economic rewards directly from their children but the most frequently mentioned reason for liking to have children is that they will care for their mothers in old age. This reason is most frequently mentioned by the Dagomba women in Tamale. The next most frequently mentioned reason is that they make a woman feel complete through motherhood.

Slight, but possibly significant, differences are noticeable in maternal role satisfaction between locals and migrants. Only 11 migrants, as compared with 18 non-migrants, reported a high level of satisfaction with their maternal roles. This may be attributable to the fact that more migrants were separated from their children which in itself is linked to the greater difficulty that migrants experience in getting help with child-care.

- 78 -

6.2 Child-care: Tradition

Ghanaian households have in the past relied upon the services of children to maintain traditional labour-intensive modes of agricultural and domestic production and processing, transportation of needed resources such as fuel and water, and petty trade. Such practices still continue today. As noted above, the need for children's indispensable labour was the major reason given 20 years ago by Dagomba parents and elders for being reluctant to send their children to school (Oppong, 1974). The mechanisms whereby all households have been able to avail themselves of such assistance, even when there were no children born to adult members of the household, or none of suitable age, or those of suitable age had been given the privilege of school attendance, have been described in several studies already referred to above: the practices of fostering of children by non-parental kin and the giving of children in domestic service by the rural poor to the urban well-to-do. Such practices have the support of customary norms, values and beliefs regarding their appropriateness and efficacy. At the same time the traditional stresses during socialisation upon the values of respect, obedience and service to elders, the importance of training for traditional domestic and agricultural pursuits segregated by sex and the conformity to social norms, sanctioned by corporal punishment, ridicule and magico-religious threats, have ensured that children remain oriented towards working diligently for the elders in their households, whether they are parents, relatives or strangers.

Meanwhile, the typical size and changing composition of domestic groups, the delegation and sharing of child-care and the prevalent fostering practices have rewarded adaptability to changing social situations and have encouraged the forging of many and necessarily more tenuous and temporary personal bonds, discouraging or inhibiting the formation of strong affective ties between the individual caretaker and child. Thus those techniques of child-rearing which exploit an affective tie between parent or other caretaker and child are not practical. High mortality, divorce rates and co-residential polygyny as well as the frequent impermanence of individual child-rearers in the home, and the practice of transferring children for a variety of reasons from one home to another, make it preferable that individual children and their caretakers do not become too strongly attached.[2]

Adaptability and conformity are useful to a child in a culture of multiple parenting and the existence of a uniform child-rearing mode eases the task of caretakers who are expected to share parental roles. A Ga woman described how adaptability was essential to her as a child.

I lived with both my parents until the age of 7 when they divorced and I remained with my father. My father married so many women. I wasn't all that happy.

I didn't trouble my step-mothers. My father taught me
from the start that whatever happens or whoever comes
to the house I have to be able to adjust myself.

Traditionally the need for a homogeneous mode of child-
rearing inhibited individual thought on the subject. To the
illiterate and semi-literate in Ghana today, child-rearing is still
largely a non-issue. To hold one's own ideas about child-rearing
would first be pointless because in a multiple parenting situation,
deviant child-rearing practices would be countered by the
practices of others. Secondly, an attempt to innovate would be
potentially disruptive. One young Ga woman, whose own mother
was educated, referred to the problems the latter had en-
countered in trying to bring up her children in the father-in-
law's house.

There was not enough space and too many petty
quarrels. I think she (mother) found it a problem
being more educated than the other women in the house.
She liked to be able to control us and make us do our
homework.

One of the older Dagomba women contrasted the norms of her
rural youth and lamented the passing of the communal approach to
child-rearing.

I feel that in our tribe it is spoilt. In the old days
anyone could correct a child and the mother would be
grateful. Now mothers don't like it and so people don't
correct others' children. I feel that is bad.

6.3 Transfers of children

Because in contemporary Ghana transfers of children with a
view to providing child services usually take place from poorer to
wealthier homes, the educated women were often recipients of
others' children, sent either to help in the home or to attend
school or both. It was also not uncommon for women to be
separated from their own children especially when their further
training or work demanded it. Twenty-one mothers had been
separated at some point from one or more children for a year or
longer and the majority of women had no strong objection to
sending a child to live with relatives if it was thought necessary.
Nearly all were prepared to delegate child-care on a daily basis.
Own mothers and younger relatives were the most common sources
of help. Indeed the majority of mothers (69 per cent) had always
had some kind of assistance available to help with child-care when
one or more children were under 7 and the rest had mainly had
help for part of the time.
The Ga mother of three below is an example.

I've not been aware of shortage of time because I have my maid and my sister helping. I have a busy life and often go to church meetings. I am not satisfied with the amount of time I spend with the children but I do take care to be with them when I am at home. I also like to stop everything and attend to them because they need the love. I think I enjoy my children's company more than most people especially when they tell me funny things.

It is an experience I have waited for too long, having children. You don't get fed up easily if you have waited long for children. You should be strict when you have to but free and loving when you can. Not so free as to spoil them. Personally, I think the best thing is to care for your own children, but where you have to further your course I see nothing wrong when you have to send them to someone.

This mother is far more concerned about the emotional needs of children than most others. Nevertheless, as a full-time worker and an active member of the church, she spends quite a lot of time away from them, and when the youngest was a year old she embarked on a two-year training course and could only see them in the vacations. She has a supportive husband who is equally concerned as she is about the children's upbringing and also adequate help in the house. Thus although she is always busy she does not feel overburdened with child-care.

Having at least a little education and being on the whole wealthier than most people, the women studied usually had the means and the desire to assume responsiblity for raising their own children, either alone or jointly with a husband.

To me it is better to let a child be brought up by its own parents. Some who go to other people become cowards because they get whipped.

There were, however, notable differences among the women according to ethnicity and migration status both in the extent to which they were ready to approve of fostering and the extent to which they had in fact lived separately from their own children. Table IV.4 shows that the difference between the Dagomba and Ga is significant for the non-migrants. It is among the Dagomba in Tamale, for whom fostering continues to be a culturally sanctioned practice, that separation is most common. It is also more common among separated, divorced and polygynously married women who are less likely to disapprove of the practice. In the case of four women who had unwanted births at a young age, the kin of the child's father took the child in two cases and in the others, the woman's parents named and raised the child. In divorce seven women kept the child or children, three left them with the husband and in three cases the sibling

Table IV.4. Mean longest periods spent separated from children under 12 years[a] (N = 54)

Age group	Ga	Dagomba
Young (18-24 years)		
Local	3.2	2.6
Migrant	.0	.0
Total	1.5	1.6
Middle (25-34 years)		
Local	.0	3.0
Migrant	2.0	2.0
Total	.8	2.4
Older (35-50 years)		
Local	1.8	4.0
Migrant	1.8	2.2
Total	1.8	3.1
Entire population	1.5	2.4

Note. The difference between the ethnic groups is statistically significant for the non-migrants but not for the migrants.

[a] In years and excluding boarding school.

group was divided between the parents. These initial arrangements for the care of children in divorce were not always permanent and it was fairly common for the children of divorced parents to move from one parent to the other, according to who was best able to support or educate them.

Women had other people's children in their care for a variety of reasons. The infertile and sub-fertile looked for children to foster as a substitute for their own. Other women who had sufficient children of their own wanted girls to help in the home. Some young kin were fostered mainly because their parents had difficulty in maintaining them or educating them, and such fostering was undertaken as part of a duty to assist kin. In addition women often had young kin of their husband to care for. Dagomba women have had more permanent help in the home from young people sent to them.

The case material presented below gives examples of kinds of fostering and attitudes of participants in the arrangements.

Fate is a Dagomba hospital nursing sister in her middle thirties.

> I have only had one pregnancy which went up to term and that resulted in a still-birth. That was four years ago. I have difficulty in conceiving and have had many miscarriages. I have fostered several children.

> The first child who came to me is called Boko. She is a Ga from Accra and she is related to a cousin of mine whose father is Ga. She has been with me for two years and I believe she must be about ten. Her mother has nine children and the husband is not helpful in looking after them. She was having trouble controlling the children. I don't think the mother will ever ask for her back. She said I should take her and keep her as my child. Boko is now in primary class three.

> Then I got Ester. She came to me at seven months and is now four years. She is my 'grand-daughter'. That means her mother is my senior sister's daughter. My niece was not married to the man because he was already married, and my sister wasn't earning much, so I decided to take the child. I rarely see the child's mother because she is now working at Bolgatanga. She only comes to visit if I am sick or at Christmas or Easter. Esther does not know yet who is her real mother. She calls my niece 'sister' and I've told her she's her mother but she doesn't take it seriously.

> Two weeks ago I got another one. She is eleven years old and she is my brother's daughter. Every time I visited the house she was crying that she wanted to come to me. She is the first daughter of her mother. I did the pagapuulana ceremony for her mother. The mother was so happy when I went for the child. If I didn't send for the child it would look as if I didn't like her. The day I went to collect her they were so happy. People will know that after all I like the mother. The mother feels that the child will get a good education with me. The girl will stay with me until she marries. I will have to try and send her to secondary school. If they are clever all the children will go to school.

Each of Fate's foster children has come to her under a different arrangement. The first child, Boko, is not actually kin to Fate but only the relative of a distant affine. Of all the children in Fate's care, this one is least likely to have much to do with her biological parents again. She has been given away to

a virtual stranger because her mother could not and her father would not support her. This child therefore can be expected to attach herself exclusively to her foster-mother.

The other two children are kin. Although they have been given to Fate, ties with the biological parents are not broken and as adults they will have obligations towards them as well as Fate. One of the children has been given to Fate under the traditional Dagomba arrangement whereby the first daughter of a woman can be claimed by the husband's sister. The pagapuulana ritual is performed on a woman in her first pregnancy by the sister-in-law who may later claim the child if it is a girl. In our educated Dagomba sample this ritual was rarely performed. Fostering of a first-born girl by her paternal aunt most often occurred when the child's parents had little or no schooling, educated parents being reluctant to part with their children.

The following account by a woman of her experiences of taking her and her husband's juvenile kin into their home shows some of the problems commonly encountered in such arrangements.

> When we first married he had a niece whom we sent to school and maintained. Also I had two girls from my side. I sent one to school but the other was already too old. My husband's niece stayed with me when he travelled abroad to study, and then when I joined him she stayed with my parents. She was from my husband's father's side. I didn't want my mother-in-law to feel that her side of the family was being left out so I asked her to bring a girl too. The girl she brought had stopped class five because she was a bit deaf. Then my husband's maternal uncle died when we were in the States. When we came back I asked for one of his children to be brought so that we could help by taking care of them. A little girl not yet of school age came, and also her brother who was a Middle Form Four leaver who had no work and was just idling in the village. I asked them to send him too so that we could see what we could do for him in the way of a job or further training.

> You see I was anxious not to monopolise my husband's house and his property. I didn't want his family to be able to say that I was taking everything of his.

> Then my aunt sent Mary to me; she is my niece, and she is now in Form Four. A year or two after Mary came I asked my husband to fetch another nephew from his village, so that we could find a place in a technical institute for him. The boy came but he didn't help in the house at all. If you asked him to do something he either didn't do it or did it very badly. My husband didn't say anything. If it had been one of my boys I would have forced him to help in the house but this one

- 84 -

just used to lock himself up in the boys' quarters. My husband took no action. My husband's little niece also became rude because her brother was there and also a maid whom my mother-in-law had sent from their village. I found them ganging up on Mary, my niece. One day the children fought Mary while my husband was around. He tried to check them and talk to them, but the next day they ran away to their brother who was teaching at Nsawam and he packed them off to their village. We were well rid of them. So I went to get another niece of mine. She proved to be a bit spoilt. She had been in the village with her grandmother who pampered her. She started ganging up with the other maid to bring friction between me and my husband. They told lies, for instance about how I was treating them. Now I just have my niece Mary and a maid whom I pay. She is an Ewe from Togo and her parents live in a village near here. I pay them forty cedis a month. She came to me when she was eleven.

Fostering of children is undertaken for multiple reasons. In the transfer of a child from a poorer to a richer home it is envisaged that the child will receive advantages in the foster home which would not have been available in the parental home. At the same time the wealthier people are often in need of domestic help, especially at the stage when their own children are very young. All these considerations applied in the case above. The wife was anxious that her husband's kin on both sides should send children to them so that they could all benefit from his prosperity. The problems she encountered with juvenile affines and kin were of the type which often discourages the educated from fostering, and make them prefer to hire young non-kin servants.

6.4 Involvement of fathers in child-care

Fathers' participation in the care of young children is limited firstly to those fathers who reside with the wife. Most of the polygynous fathers thus have little to do with young children since the women in this sample with at least a little education are rarely found in co-residential polygynous situations. Moreover, polygyny is associated with a traditional and non-egalitarian mode of conjugal interaction in which child-care and domestic work are strictly the woman's sphere of activity. Therefore it is not surprising to find only one out of 11 polygynous fathers contributing even a little to child-care, whereas in monogamous marriages about a fifth participated a lot and a further third participated a little.

Most of those Ga who lived with their husbands (12 out of 24 ever married) had at least some help from them in child-care, and a few of them had a lot of help from husbands. The migrant Ga

was the group with the greatest participation in child-rearing by husbands, and this group also had the highest incidence of monogamy and conjugal co-residence (see table IV.5). Theirs were also the homes with the least domestic help available from sources outside the nuclear family.

Table IV.5. Fathers' involvement in child-care[a] by ethnicity, wife's age group and migration status

Age group	Mean scores	
	Ga	Dagomba
Young (18-24 years)		
Local	0.3	0.3
Migrant	0.5	0
Middle-aged group (25-34 years)		
Local	0.8	0
Migrant	1.5	0.4
Older		
Local	0.6	0
Migrant	1.0	0.6

[a] Fathers' participation in play and physical care of children was scored: none = 0; some = 1; a lot = 2.

Dagomba women had little help with child-care from husbands, and husbands gave more help in migrant homes in Accra than in the home town Tamale.

Such marital disagreements as are reported on the subject of child-rearing all involved the wife wanting the husband to participate more or to be more strict, or else the husband complaining about the wife being too harsh with the children. A Dagomba woman who prided herself on her strictness and ability to control her children said:

When I get annoyed with the children I beat them. My husband thinks I shouldn't be so strict.
[Woman with medium level of education, married to man with high level of education]

- 86 -

Mothers were most inclined to express dissatisfaction with the behaviour of the children's fathers where the training of adolescent and older boys was concerned. Mothers wanted fathers to be authoritative with boys and were dissatisfied when either through lack of interest or permissive attitudes they were not.

> The man doesn't spend much time in the house so I do everything with the children - train them and discipline. All the teenage boys' problems that we have, I have to deal with them. I am a disciplinarian. I restrict their movements. They may think I don't like them but they will appreciate it in the end. I've stopped asking my husband to play a part in disciplining them because he does nothing. I feel it's not fair....Because my husband refuses to play an active part in disciplining the boys they seem to like him more than they like me.
> [Dagomba woman with Ashanti husband]

> We have disagreed on a lot of things. You have to obey your husband and then if things turn out badly you know it is his fault. My background is different to his. My father was hard because he had more boys than girls. He was very strict. My husband wanted the children to be free. I felt he should discipline them more.
> [Ga married to Ewe - mother of five boys and a girl, ages 10 to 24 years]

6.5 Consciousness and innovation

An attempt was made to assess differences in expectations and activities regarding child-rearing on the basis of what women said and where possible observations of parent-child interactions. Two simple but important aspects of expectations for the parental role were compared; first, the extent to which conscious thought was given to child-rearing; and secondly, the extent to which ideas on child-rearing were innovative in relation to culturally prescribed norms.

These two dimensions of maternal role consciousness and innovation were highly intercorrelated. Twenty-seven women showed no indication of either trait, 12 a certain degree of each. Nine were very conscious but only partially innovative. Only eight women were both very conscious of their child-rearing practices and highly innovative. Women in Accra, the more modernised cosmopolitan centre, tended to be more conscious of child-rearing practices than those from Tamale (13 women in Accra as compared to four in Tamale were highly conscious). Women who were conscious about child-rearing were also more likely to appreciate companionship with their children. Of those who gave some thought to child-rearing, some believed that the

methods of the previous generation were best on the whole.
These included a concentration upon obedience and serviceability.
On the other hand innovators generally had a more child-centred
approach to child-rearing and gave more consideration to the
child's emotional needs. About half were observed to innovate to
some extent using what they thought were more modern methods
or ways they preferred to customary usage. Innovators tended
to have married later and to be in Christian or registered
marriages rather than Muslim or customary, for both innovation
and consciousness were closely correlated with levels of education,
those who were markedly innovative having the highest levels of
education, as had their husbands.

Many of the less educated women, when questioned about
child-rearing, mentioned only the physical aspects of child-care.
They talked about the quality of meals, clean clothes, and the
use of toothpaste instead of the traditional chewing stick. The
experience of their own traditional childhoods and the lack of
models for alternative modes of child-rearing make innovation
difficult. A highly educated Dagomba woman expressed ambi-
valence about innovation in child-rearing when she compared the
behaviour of her older and younger children.

> The young ones are probably more extrovert than the
> older ones because they had both of us (parents)
> around throughout their childhood. It has made them
> more confident though academically the older ones are
> better. Because of my upbringing it irritates me to
> see the young ones so outspoken.

The changes in child-rearing methods most often referred to are
minimising the amount of corporal punishment and influencing the
children's behaviour by talking to them about it. A few seek
even further change by looking for a personally intimate relation-
ship with their children. The more child-centred parents were
easily distinguished from the others by their propensity to talk at
length about individual children.

The following excerpts from the focused biographies all show
some degree of innovation in child-rearing.

> In training children you have to study the child's
> character and then you will know what to do. I believe
> in letting them be a bit free. My mother was strict and
> so was my aunt. Illiterates treat their children with
> some sort of force which makes them timid.
> [Ga in Accra, highly educated, late first birth, one
> child, divorced]

> I do treat the children differently from some people. I
> play with them. Then when I want them to do some-
> thing I stop playing and they do as I say. I let them
> take it in turns to choose the dish for the day. I find
> it very easy to control them.

[Older Dagomba woman with medium level of education
- sub-fertile, polygynously married, fostered several
children including the child of a co-wife]

Razak has just got himself apprenticed to a bigger boy
who makes toy lorries out of tin cans. I'm pleased
about it. He spends hours on the work, cutting open
tin cans with a knife and flattening them. Most mothers
aren't interested in their children doing that kind of
thing. I see it as creative and useful in teaching him
mechanical skills. I am not that bothered about chil-
dren soiling their clothes. So many people won't let
their children play with things for fear of getting them
dirty. Razak is quite independent now. I've been
travelling up and down the country to seminars and
meetings and he is quite happy with the maid. I feel
quite competent to bring up a boy myself. I can't help
it if his father is not interested in becoming close to
him. I am quite strict with him. He talks to me a lot,
about what he has done at school and so on and I enjoy
his company. At times though he refuses to do some
tasks because he says "this is not boys' work". So I
say to him "do I have a girl?" I try to train him to do
everything but he sees what other people do and won't
always co-operate.
[Dagomba with one child, highly educated, late first
birth, sub-fertile, polygynously married]

6.6 Ambition and individualism

All the women desired their children to do well in the modern
world and to be equipped with the necessary education, and
vocational and professional skills. They themselves enjoyed the
privilege of schooling and many have had opportunities for
salaried employment. They feel their children must also enjoy
these chances and to an even higher level, particularly in view of
the continually escalating cost of living and the rising demand for
educational certificates. Most women are prepared to go to great
lengths of physical and mental exertion and self-discipline in
order to provide their children with the means to this end.
Thus it is not surprising that the parental role is the second
biggest source of role strain, especially material, after the
domestic role. These women, as we have seen, are mothers in a
cultural context in which many children are still obedient
providers of services to relatives, while others in contrast are
expensive consumers of schooling, books, clothes, pocket money,
transport and leisure. They all try to put their own children
in this second category. If child labour is needed in the home
for chores or baby nursing during school hours they see to it
that, as far as possible, this assistance is provided by other
people's children, not their own. However, as indicated, there is

still some mingling of traditional and innovative attitudes to children and their care and what they are expected to give to or receive from their parents, and some mothers still remain more traditional than others.

A significant aspect of the signs of innovation witnessed are their close association with reluctance to foster children. Only ten of the innovative mothers approved of fostering, while 24 of the rest approved - a statistically significant difference.

Thus the greater concern of the more highly educated and innovative mothers to bring up their own children and to do it in their own way points to a growing individualism in parenthood. The idea that offspring belong exclusively to their parents and that the latter are by far the best people to bring them up is new in West Africa, where transfer of children to kin or fostering is traditionally widespread as observed above. To believe as a mother that nobody else will do quite as good a job of raising the child as oneself and to have one's own ideas on child-rearing is innovative and individualistic, in terms of the traditional kin group norms of the Ga and Dagomba.

Closely linked to individualism in parenthood and also a characteristic of the parent with education is the desire for children who will do as well if not better than oneself in school and at work, hence the desire to produce children who are advantaged in the competitive spheres of school achievement and job seeking. Such advantaged children are costly to raise financially, and may be costly in terms of the mother's time too if the mother feels that she should devote a lot of personal attention to the child.

As R.A. Levine (1984) has written, the behaviour of mothers in a particular setting reflects the prevailing investment strategy, as interpreted in local cultural tradition. In traditional Ghanaian settings, as elsewhere, the focus is on the physical survival of successive children, who are trained in obedience and filial piety. In the more modern settings the mothers lavish time and material resources on each child individually in the hope that their life chances will be improved. Moreover, as Levine notes, "...[such mothers] are less concerned than agrarian mothers about the dangers to family life of producing a demanding and disobedient child" (p. 2).

6.7 Maternal role innovation and role attributes

There is interesting evidence that innovation in child-care is also often related to a number of other role attributes. These include for instance late, monogamous marriage in church or registry to co-resident professional husbands with whom the relationships tends to have high salience and to be unusually joint and participatory. Husbands share more in leisure pursuits and child-care and wives perceive their conjugal relationship as important both for economic status and personal happiness and

companionship. Thus change in the maternal role is in many cases linked to change in the conjugal role.

Innovators in child-care also tend to feel their that domestic roles are more important than the rest and have far better material resources in terms of accommodation, consumer durables and transport. They more frequently feel social prestige from their domestic positions, given that their standard of living tends to be conspicuously higher, and thus feel satisfied. However, there is also a tendency for more feelings of strain or conflict in relationships with co-residents.

Being mainly highly educated, half of the innovators are also women engaged in professional and clerical types of occupations and innovators as a whole place greater stress on their occupations than the rest, gain more satisfaction and feel a greater sense of social status accruing from it.

They are also more active than the other women in community affairs, give these activities far greater priority, feel a sense of satisfaction and prestige from their participation but at the same time feel some element of strain in terms of lack of time to do all that they would like to do. These findings do not apply to individual leisure pursuits.

The various signs of different role attributes - conjugal, domestic and occupational - linked to innovations in child-care, are all clear indications of the ways in which higher education and consequent social and spatial mobility may have a pervasive impact on women's roles. In many cases these changes involve relationships with children and husbands which are more egalitarian, intimate and personalised than is traditional and occupations which give important individual economic and social rewards.

6.8 Conflict and strain

Half of the women throughout their adult lives had been combining child-bearing and care with income-earning activities and nearly all the rest had done so for much of the time. Since varying amounts of this activity took place outside the home (as indicated above), it is not surprising that many women gave evidence of role conflict and a third showed indications of time strain even though, as we have seen, there is considerable delegation of child-care responsibilities. Significantly, it was migrants living away from their home towns and most of their relatives who experienced most conflict between their parental and occupational role activities. Thus the extent to which potential conflict and strain were minimised or avoided by delegation of child-care to relatives and maids was an important factor differentiating the women.

Monogamously married women were more prone to complain of time strain. Those who felt time strain least were the Dagomba in Tamale, since they were most likely to have plenty of domestic assistance from relatives, children and others as illustrated above.

For both the Dagomba and Ga perceptions of lack of time became more salient with age. Maternal time strain appeared less important than financial strain in rearing children.

Financial strain was a problem for those who had neither salaries which were felt to be adequate nor sufficient material support for their children from their husbands or the fathers of thei children. Such financial strain was particularly in evidence among women in Tamale, especially those married polygynously and the older age group.

In the following case a Ga mother of three children, with a medium level of education living in Tamale, tells how she minimises any financial or time strain resulting from child rearing or domestic work. Home sewing cuts down her costs and training the children to do domestic chores cuts down on time strain although sh often suffers from fatigue.

> My children have not been a financial problem. One needs money to raise a child and most of my colleagues have problems with money and can't look after the children as well as I can. I sew and that also makes things a bit cheaper.

> I don't find looking after the children a strain on my time. I don't give my children much attention. When I close from work I rest, cook and then rest or sew, maybe give them half an hour home lessons and then go to bed.

> One shouldn't use the cane often. Only very sparingly. One should talk to the child. With my children when I am doing something in the kitchen I call them to learn how to grind pepper and so on. The girl comes but not the boy. I give them household task - sweeping, watering the backyard garden. The boys help to feed the chickens. When the maid goes they will have to help more since I don't intend to get another one. I supervise their work.

The continuity of some of the traditional expectations and practices have now been indicated, practices which spread the responsibilities for children among a group of relatives and cut down maternal time required, diminishing the potential conflicts and strains involved in simultaneous motherhood and occupations outside the home. New elements in child-care have also been identified - greater consciousness, innovation, individualism and ambition - leading to potentially more costly child-rearing outcomes for mothers.

Such changes in the maternal role involving greater stress on modern approaches to child-care and child quality are demonstrated to be associated with a number of modernising elements in other roles, including greater flexibility and emotional salience in marriage, a higher standard of living within the home, greater

concern for community life and participation in it and involvement in status-enhancing jobs.

6.9 Conclusion

Aspects of the 60 women's roles have now been examined and some of the associated expectations, activities and resources described. Where relevant, differences by age, ethnicity, migration and education have been indicated. Illustrative excerpts from the individual biographies have served to give further insights, especially to those unfamiliar with the cultural context. An aim has been to depict the norm, the average or the modal tendencies where appropriate for this set of women, but also to account for a range of differences and variations, indicating that some women approximate customary behaviour patterns and expectations more than others. Directions of some desired changes have also been articulated, as well as areas of conflict, dissatisfaction and attempted innovation.

In Chapter V the subject is births and the expectations and practices affecting their timing, number and control. Potential impacts of higher education, modern sector employment, dwindling kin support, community involvement, changing domestic aspirations, the nature of the conjugal role relationship and conscious and innovative child-care are all observed and discussed and their outcomes assessed in terms of lowering of fertility and adoption of modern contraceptive techniques.

Notes

[1] It should be noted that the scores for satisfaction and social status rewards associated with the maternal role are negativ ly affected by a few infertile or sub-fertile women, as well as young women who have not yet started child-bearing.

[2] Cf. Erny (1981, p. 69 ff) regarding the formation of the social ego in traditional African society and the ways in which customary socialisation practices are geared towards ideals of conformity, interdependence and submission to the common will. "In the traditional African family...the child establishes relationships with a distinctly larger number of persons [than in the modern Western family] but by the same token the relationships and feelings they engender are more diluted, less consistent, more relaxed and more diffuse" (p. 69). Also see Stone (1977) regarding historical evidence on these same issues from England.

CHAPTER V

BIRTHS: TIMING AND NUMBER

Without doubt the maternal role is still given pride of place among all roles in spite of its lack of economic rewards (unless for the elderly) and in spite of its being a cause of varying levels of financial and time strain in terms of fulfilling children's needs for care, clothes, schooling, living space and food. It is also a focus of deeply felt ambition and goals and of considerable desire and pressure for innovation and change with regard to child-care values and practices, which are radically altering the costs and outcomes of child-care.

Here the timing of the first and subsequent births is examined, as well as some of the factors which may be influential, such as higher education and training, inability to establish or maintain a suitable conjugal relationship and the effects of kin pressures. Next the numbers of births desired and achieved are analysed in relation to age, ethnicity, migration status, level of education and relative wealth. Some women have fewer children than they want. Others have more than in retrospect they might have preferred. An important difference between women is the extent to which they consciously control births, using modern contraceptive methods. These differences are examined within the context of interesting contrasts in other roles and the extent to which there is experience of conflict or strain.

1. Timing of the First Birth

The average age of women at the birth of the first child was 23.6 years for the Ga and 21.3 years for the Dagomba, a reflection of the impact of higher education on the postponement of the first birth.[1] Actually, nine first births (five Ga and four Dagomba) were the outcome of an unplanned and unwanted pregnancy which occurred before the mothers were 20 years old. What distinguished these births from other premaritally conceived but socially approved births was that the man responsible was either not willing to marry the mother or was not considered a suitable husband, and in addition the woman's education in some cases was cut short. A further eight women had prevented such unwanted births by pre-marital abortions.

First births which curtail women's education are one of the factors involved in the link between educational level and age at first birth. Many women never resume their education after this setback, or if they do, they are hindered from going as far in education as they might otherwise have done. The main reason, however, for age at first birth being linked with educational level

is that most women deliberately postpone their first birth until they have reached the desired level of education. This trend emerged most clearly among the Ga women. The mean age at the birth of the first child was 21.5 years for those with a low level of education, 22.4 years for those with a medium level, and 27.5 years for those with a high level. It is significant also that three of seven Ga women with a high level of education had had a pre-marital abortion. Since a substantial proportion of young women conceive while at school or training institutions the option of abortion is a very important factor in their educational prospects (Oppong (ed.), forthcoming; Akuffo, forthcoming).

Age at the birth of the first child rose less steeply with education among the Dagomba than the Ga. The average age was 19.2 years for the Dagomba with a low level of education, 20.6 years for those with a medium level, and 23.4 years for those with a high level. Just over half of the highly educated Dagomba women embarked upon important stages of their education after the birth of one or more children, and several had only been able to take their education beyond elementary level by breaking out of an early first marriage. The pressure upon Dagomba women to marry young, and the costs to a mother of going away to study while her children are young, are described in the following excerpt from a focused biography.

I wouldn't like my daughter to marry at 19 as I did. I would prefer her to complete her education first. I find some difficulties in being a wife, a mother, and a student. If I had finished my education first I would have been more free to devote my energy to the children and not leave them behind with my mother as I have done. In Dagbon great importance is attached to marriage. If you are not married by a certain age they will ask whether men don't like you, or whether you choose not to marry so that you can flirt. You hear remarks all the time even if your parents don't trouble you.

It is interesting to note that the Dagomba women who bore their first child outside their home area (seven) had an average age of 23.2 years at the birth of their first child as compared with 19.6 years for those who had their first child in the home area (19). The latter are likely to have been subjected to more intense pressures to marry and have children at an early age by their kin, peers and community.

2. Spacing of Births

The commonest causes of interruption of a woman's child-bearing career are related to her marital situation, including widowhood, divorce and extra-marital births. Such events either curtailed or interrupted the course of child-bearing for 20 of the

women. Occupational factors were associated with the interruption or cessation of births for 12 women. These were cases where a woman ceased child-bearing in order to pursue education or a career but intended to continue child-bearing again after some time. Five of these cases were also included in the numbers of those whose child-bearing was affected by marital factors. They are women whose decision to divorce was linked to the desire to pursue a career or further their education. All of these were Dagomba; two had been married early against their will, and three had voluntarily married men who later opposed their continuing education or careers.

There was a difference in distribution of education levels between the group whose child-bearing was interrupted by marital factors, and the group affected by occupational factors, the latter having much higher overall educational status than the former.

Looking at the older women alone, whose child-bearing careers were complete or nearly so, we find that half of them (ten) had had their child-bearing interrupted or curtailed on account of their marital situation. Only three had ceased bearing children, temporarily or permanently, in order to pursue their education or careers. Many of the women in the older group could not have pursued education after child-bearing if they had wanted to, because of the regulations at that time which prevented married women and mothers from being accepted on many courses.

All of those who started child-bearing at 26 years or later (eight women), aimed to have their children without interruptions, and most were successful though the group did report above average problems with fertility and three expressed anxiety on that account.

For the Dagomba, polygyny has significance for birth spacing. The traditional long period of post-natal sexual abstinence is acceptable to men partly because another wife's sexual services are likely to be available when one is abstaining. A school teacher described how the system worked in her marriage.

He does his natural family planning. This one comes on, he stays with her, she gets pregnant and when she gives birth the other one comes on. My co-wife now has two children. Her youngest is 4 years old and she is pregnant again now. It never arises that he can't sleep with anyone.

The availability of other contraceptive methods, however, reduces the need for lengthy post-natal abstinence, and polygyny ceases to be valued by educated women for its birth-spacing function.

3. Procreation and Marriage

Their marital situation is of great significance to women for child-bearing. Divorce and never marrying are associated with

fertility under-achievement, while achievement and over-achievement of fertility goals are associated with stable marriage. Marriage is the preferred child-bearing and child-rearing context both for the social status and economic support it offers. Inability to secure a sufficiently economically supportive husband makes it difficult for a woman to fulfil her reproductive goals or her maternal responsibilities to her satisfaction.

Further generalisations about the relationship between marriage and procreation in Ghana cannot be made without drawing attention to differences between ethnic groups. The Ga and the Dagomba differ in the articulation of the conjugal and maternal roles. Because in Dagomba society children belong absolutely to their fathers and bastardy is a disgrace, divorced and single women have very little scope for motherhood. Marriage on the other hand enhances the maternal role of even an infertile Dagomba woman because some of her co-wives' children will be put in her special care. The Ga by contrast value mother-hood whether or not it is accompanied by marriage. For conception to precede marriage is appreciated whereas amongst the Dagomba it is not. Divorced Ga women find it relatively easy to gain custody of their children, but Dagomba do not, especially where male children are involved. If she has no husband a Ga woman can still bear and raise her own children without incurring social disapproval. Thus married status is more important to the Dagomba woman both for bearing and bringing up her own children than it is for a Ga woman.

As was discussed in the section on conjugal relations, the whole purpose of marriage is considered to be procreation. An indication of the importance of procreation for marriage is the fact that many Ga men do not begin the formal procedures leading to customary marriage until the woman is pregnant. Four of the women in the study had steady lovers only waiting for them to conceive before marrying them. Three of them were co-habiting with the lovers. Only one had never married or had a child before, but all were currently experiencing some kind of fertility problem, with either failure to conceive or miscarriages.

4. Kinship and Procreation

The concern of kin regarding a relative's child-bearing is a recognised aspect of family life in Africa and elsewhere. Awareness of kin and in-laws' expectations regarding their fertility was evident from statements by many women in this study.

> I know that my mother would like me to have about eight children so that she could have many grand-children.
> [Dagomba woman]

> With Ghanaians the relatives of the man feel that it is very necessary to have a child when you marry. If

after one or two years you have no child the relatives
will tell him to get another woman... Most of us believe
that when you marry you should be pregnant, but I
don't believe in that.
[Ga woman]

A few women discussed their own family size goals with reference
to the kin group. A highly educated Ga woman with four chil-
dren explained.

I would have wanted six children because my mother
only had two, to make up for her lack of numbers.

The Dagomba woman quoted below had her child-bearing attitudes
affected both positively and negatively at different times by
kinship considerations.

My reason for marrying was first and foremost that my
mother wanted a grandchild. I was the first daughter.
I owed her that much. All her mates had grand-
children. I'm not sure how many children to have
yet. Once I discussed it with my husband and he
wanted three and I said four. Now that my mother has
died I have so many responsibilities towards my
brothers and sisters that I am rethinking how many
children of my own to have.

Though not many women actually discussed how many children
they wanted with reference to kin, it seems significant that
women whose family size desires were unusually high for their
education level, and who therefore appeared to be deviant,
actually came from unusually small sibling groups. A woman with
a medium level of education who wanted five children was the only
child of both parents. A highly educated, late-marrying Ga
woman who was her mother's only child and one of her wealthy
father's three children wanted four children and when one of the
four died went on to have a fifth.

5. Family Size

Two-thirds of the women perceive themselves as not yet
having finished child-bearing. Only 8 per cent have as many
children as they desire and 12 per cent admit to having more
than they want. Differences in mean births by ethnicity are not
significant in any age group (see table V.1). In addition to their
own children the majority of the Dagomba women (17) have step-
children (mean 2.6 children) as do nine Ga women (mean 1.3
children).
For the total population the mean number of births preferred
is lower than four, with no differences between the ethnic groups
(3.7 for the Ga as compared to 3.8 for the Dagomba). These

Table V.1. Children by ethnicity, age and migration status

Age group	Migrant status	Ga (N = 30)				Dagomba (N = 30)			
		Mean no. births	Mean no. births preferred	Mean no. step-children	Mean no. mothers' children	Mean no. births	Mean no. births preferred	Mean no. step-children	Mean no. mothers' children
Young	Local	.8	2.8	.6	6.6	1.2	4.0	3.0	5.2
	Migrant	.1	4.4	.0	6.4	1.0	4.0	1.0	8.4
	Total	.8	3.6	.4	6.5	1.1	4.0	2.2	6.8
Middle	Local	2.0	3.2	2.8	5.6	2.4	3.7	2.6	3.6
	Migrant	1.8	3.8	1.5	6.0	2.0	4.0	2.6	7.0
	Total	1.9	3.5	2.2	5.8	2.2	3.8	2.6	5.3
Older	Local	5.8	4.7	1.2	4.4	5.4	3.7	6.0	4.4
	Migrant	3.2	4.0	1.0	7.6	3.4	3.7	.7	5.2
	Total	4.5	4.3	1.1	6.0	4.4	3.7	3.0	4.7
Total		2.4	3.7	1.3	6.1	2.5	3.8	2.6	5.6

preferences and achievements contrast quite markedly with the birth achievements of their own mothers, who had an average of almost six children.

Some differences in family size achievements and preferences are apparent by educational level, wealth, migration status and size of family of origin. Thus among all women there are differences in mean numbers of births by migration status. The migrants of both ethnic groups and all ages have on average fewer children than the non-migrants although they do not necessarily want fewer children (see table V.1). Again there are noticeable differences in the expected direction between family size desires of women with higher education (mean 3.5 desired) and a lower level of education (mean 4.1 desired). Such a difference is not associated with husband's level of education. The difference is, however, even more sharply accentuated among those few women who are relatively wealthy.[2] Fourteen women were assessed as well off and among these the eight with higher education desired a mean family size of 3.1, the three with medium levels of education 4.7 and the three with low levels 5.0.

Women whose own levels of education are higher than those of their husband have lower family size preferences (3.5). The ten women in this group include some with high, medium and low levels of education, the latter being married to men who are illiterate or nearly so. Half of the marriages are polygynous. The husbands in these marriages are fairly well off, while the husbands of those in monogamous marriages are notably poor. In both types of situation, the woman is heavily dependent on her own resources for achieving good educational opportunities for her children. At the same time, those whose husbands have other wives and children are less likely to exert pressure for many births. Several of the women in this category indicated that their husbands left it entirely to them to decide how many children to have. For example, one wife commented about her husband: "He has plenty of children already, so he doesn't care how many I have". The 28 women married to men with higher education than themselves desire an average of 4.2 children.

In the previous chapter, the close association between levels of education and innovation in child-rearing were demonstrated. Here some variation in preferred family size is observed, linked to consciousness and innovation in child-rearing. The desired quality of children in terms of conscious individual investment of the mother's time is linked to the quantity of children preferred. The range is between three and four children.

Thus the 27 mothers who give very little conscious thought to child-rearing and do not innovate in child-care methods at all have a mean desired family size of four children. The 16 who gave some thought to child-reading and do not follow custom entirely want an average of 3.6 children. The nine women who gave a lot of thought to rearing their children and innovate to some extent want 3.3 children. The eight very consciously thoughtful and highly innovative mothers want 3.1 children. The correlations between level of maternal consciousness and maternal

innovation with family size preferences are both statistically significant.

5.1 The older mothers

All except three of the women in the older group (35-50 years) consider that they have completed their child-bearing. The mean for all is 4.4 births (see table V.1). Five have failed to achieve their child-bearing goals and seven have exceeded them, or at least have had more children than they would in retrospect have wanted. For only six do family size preferences match achievements.

Before going on to discuss the causes for these women's preferences matching or not matching their family size achievements, it is relevant to recall two historical changes described above which have taken place in Ghana during the child-bearing years of these women. The first is the arrival of widely available family planning facilities. This occurred in the early 1960s, and so the older women in the sample have been fertile during a period of change in the conditions for the control of reproduction. The second historical change taking place during this period, and of relevance to people's fertility desires, is the steady decline in living standards and economic prospects for most educated Ghanaians. From the late 1960s to the present time, as we have already described, real wages have fallen steadily and the costs of maintaining and educating children have risen sharply.

Nearly all of the older women who have had five or more children cite four as being the ideal family size. Reference to the cost of living is often made when talking about family size. For example, "If I had 'known how hard things were going to be, I would only have had four" (mother of nine).

From the focused biographies, it is possible to see why some people have had more or fewer children than they would have wanted. The cases of under-achievement and over-achievement can shed much light on the sequential processes of fertility decision-making. Below is a brief presentation of the circumstances of under-achievement and over-achievement in the older age group.

(i) Those who still intend to have more children (older women)

These three women are potential under-achievers. Their hopes of having more children may never be realised. The causes are social, not physical. Their basic problem is in finding a husband who will be acceptable to them and provide for the two additional children that each wants to have.

Zenabu, the daughter of a Dagomba chief became pregnant by a cousin at the age of 17 and therefore a

"family marriage" became necessary. Although such a
marriage was customarily acceptable the circumstances
under which this one occurred were not considered
desirable. She had a second child with the man before
he went abroad. When he came back to Ghana on
holiday, he told his parents that he was marrying
somebody else and did not want Zenabu any more.
Now, 14 years after the birth of her last child she is
still looking for a mature, responsible and reasonably
well-to-do man who will marry her and with whom she
can have two more children.

Memuna, the only member of her sibling group who had
been to school, had a salaried job which brought her
into contact with trained people from all over Ghana.
She had two children each with a different educated
southern man and each of whom she hoped would marry
her. Neither did, and in the Dagomba community her
chances of getting a husband of the kind of status that
she as an educated woman wanted were very slim. Her
last child was born ten years ago and died soon after
birth. Now at 40 years old she still says that she is
hopeful of finding the right kind of man to marry.

Miss Amartefio, as a low paid Ga clerical worker,
divorced and living outside her home area - Accra
- found it too difficult to maintain her three children.
She therefore sent them all to their father. The
youngest child is now 8 years old and Miss Amartefio
now has a steady boyfriend and is likely to become his
second wife. She hopes to have two more children with
him.

The three women in the older age group who still say that
they want more children have all had their child-bearing inter-
rupted by marital instability. In the first two cases this seems
likely ultimately to lead to below average fertility, since the
women may never succeed in creating the conditions under which
they would like to have another child. In the third case, marital
instability looks as if it may lead to more births, because the
woman intends to produce a separate set of children for each
marriage.

(ii) The under-achievers

Three women in this group were physically sub-fertile. The
other two had problems similar to those of the women described
above.

Leila (Ga) was monogamously married to a man and had
five children with him before he took another wife.

- 103 -

She found that she could not tolerate the polygynous life and so divorced. Her five children would have been enough for her but for the fact that two of them died in infancy, including the only girl. She therefore considers herself to be deprived in not having as many children as she wants and if she could have tolerated the marriage would have wanted to go on and have another child.

Miss Quartey's failure to establish a stable marriage prevented her from having as many children as she wanted. She explains the problem quite clearly.

> I would like to have had six but the spacing was a problem. Because I never had one good husband to take care of me there was no continuity. I would have wanted six children because my mother only had two - to make up for her lack of numbers. I was just not lucky. Most girls move with men and end up having a proper marriage with one. If my daughters are lucky, they will stick with one, and not move from man to man as I have done.

> Despite her problems with their fathers, Miss Quartey, who is Ga, has succeeded in having four children and giving them the best of opportunities in education. Her desire to have a large number of children in order to make up for her mother's lack of children is indicative of the importance of uterine ties.

The above cases illustrate how much more stressful and problematic it may be for Dagomba women than for Ga women when they do not have stable marriages. For the Dagomba there are very strong social pressures on women not to have children without being married. Divorce and remarriage are common amongst the Dagomba, but for educated women, who want a husband of a certain social and economic status, an injudicious first marriage or reproductive liaison can be a serious impediment to remarriage, particularly if they are averse to being a junior wife with illiterate senior co-wives. Such pressures upon the Ga women are less acute but they do need, if not a husband, at least a man who will be willing and able to contribute towards the costs of raising the children. Even if like Miss Quartey they can afford to raise the children themselves, they still suffer, as she put it, from lack of continuity in their child-bearing careers.

(iii) The over-achievers

Of the six women categorised as over-achievers, two wanted all the births that they had, but assert that under present-day conditions a smaller number would be quite enough. These retrospective over-achievers had eight and nine children respectively but even they eventually curtailed their reproduction, one by using an IUD and the other by sterilisation. The other four all actually had more births than they wanted. One conceived despite having an IUD, and another while taking oral contraceptives. The other two cases are described below and illustrate the kind of problems faced by women who want to limit family size in a pronatalist society.

Mrs. Odoi (Ga) had her five children before family planning became widely available. She was ambitious, wanting to establish as good a career for herself as possible. The only safe means of birth spacing available to her was the traditional post-natal abstinence.

> I practised abstinence to space the children. We didn't have much money and I felt it was necessary to limit family size. After the third child he said that he didn't want me to abstain for so long. This led to a quarrel and I went to live with my mother for two years. Then I came back and conceived the fourth one, Gifty. Rebecca followed too soon. I'm not quite sure what happened there. After Rebecca, I told him it was too much and persuaded him to let me go to London and I was there for ten years altogether.

Thus by periodic absences from her husband, Mrs. Odoi managed to control her fertility to some extent.

Mrs. Nortey (Ga) and her husband are both low-income government workers. She is a telephonist. They have been posted far from their home area and have no income other than their salaries. After five children she did not want any more and so had several abortions before the arrival of a family planning clinic.

> The cost of living is too high to be having many children. About four or three is enough these days. I have had three D and Cs. That was after I had my children and before I got the loop. When the Family Planning was introduced I heard about it and went there.

5.2 The middle age group

The middle age group (25-34) is currently the most active reproductive group in that most of its members have started but not yet finished their child-bearing. This is also the group reporting the lowest family size preferences and with the highest proportion of systematic contraceptors. Only two of the women in the middle age group have already achieved their fertility goals. This might appear anomalous, since some of them have fertility goals of three or two, but can be accounted for by the fact that those with the lowest fertility goals also tend to be the most highly educated and to have started their child-bearing late.

Seventeen of the 20 women in this group have been controlling their fertility by means other than abstinence. Three have had fertility problems and been receiving treatment. Only one fully fertile person has relied on the traditional abstinence period alone for spacing and she intends to start contraception after the next birth.

5.3 The younger women

Seven of the women in this group had not yet commenced child-bearing. The fertility desires of the group matched those of the sample as a whole. It seems likely, however, that many of them will modify their present family size ideals as they progress further in their child-bearing careers and face the difficulties of raising a family, as the women in the middle age group have clearly done.

5.4 Deviants

The women wanting three or fewer children comprised one-quarter of the sample. They were concentrated in the middle age group (25-34) which is the most active child-bearing group. Ten of them were Ga and six were Dagomba. Their educational level was higher than that of the sample as a whole. Half of them had a high level of education and only two had a low level. They also included most of the women with a late age at first marriage. These women feel the physical stresses of child-bearing and child-rearing more acutely than the younger women, and are also more child-centred than most in their approaches to child-rearing.

The other deviant group comprised seven women who desired a family size of five children or more. Five of these women had a low level of education. The two who had a medium and high level of education were the daughters of parents who had few children, and their deviance can be explained in terms of their desire to compensate for their parents' lack of numbers. (These examples are more fully discussed in the section on kinship and procreation above.)

6. Birth Control

Fewer than a quarter of the women have never used any form of contraceptive but less than one in three are systematic users. The rest use methods only erratically. Contraception was slightly more frequently used by Ga women than Dagomba and more frequently by residents of the capital Accra than Tamale, thus including more Ga non-migrants and Dagomba migrants (see table V.2). There were, however, no significant differences in use by marital status or religious affiliation.

Table V.2. Mean number of abortions and scores for contraceptive practice by ethnicity, age group and migration status [a]

Age group	Migrant status	Ga		Dagomba	
		Mean no. of abortions	Mean score for contraceptive practice	Mean no. of abortions	Mean score for contraceptive practice
Young	Local	.8	1.2	.4	.6
	Migrant	1.2	1.0	2.2	1.2
	Total	1.0	1.1	1.3	.8
Middle	Local	1.8	1.4	.2	.6
	Migrant	1.0	1.2	.0	1.6
	Total	1.4	1.3	.1	1.1
Older	Local	.4	1.6	.0	1.0
	Migrant	.8	.8	.0	.8
	Total	.6	1.2	.0	.9
TOTAL		1.0	1.2	.4	.9

[a] Contraceptive practice was scored: Never used = 0; erratic use = 1; systematic use = 2.

Abortion is also a commonly used method of birth control. Seventeen women admitted that they had terminated one or more pregnancies by voluntary abortion. Fifteen of these were women who used contraception only erratically. The remaining two

claimed to be systematic users. On the whole Ga women had resorted to abortion more often than Dagomba women, the young and middle aged more so than the old and among the migrants rather than those living in their home areas. In fact it was three of the young Dagomba women living in Accra who had the largest numbers of induced abortions for any sub-group by ethnicity, age and residence - one admitting to six and another to three.

The patterns of birth control vary considerably. Thus the middle aged group includes women using contraception and abortion in different contexts related to the phases of their marital and occupational careers and consequent social and physical constraints.

As we have already described above, many of them, like hundreds of their countrywomen, have continued their education and professional training when already in the middle of their child-bearing careers, thereby necessitating a long space between births at some stage. Others, as noted, have postponed child-bearing until they have reached a desired stage in their education or career. For all the demands of work, jobs and income-earning of one kind or another continue throughout the child-bearing years and often constitute the reasons for extra care in spacing births.

As indicated, most women are only part-time and intermittent housewives and mothers. Moreover, divorce and marriage have great influence on people's fertility goals.

Fuseina's (Dagomba) case provides an illustration of a context of child-bearing and birth planning:

As a child I stayed with my grandfather and he made sure that all the children in his house went to school. I hadn't finished middle school when they married me by force to a certain chief at Walewale. I kept on running away but it was of no use because they always brought me back and I had to marry him. I was the fourth wife. I had three children with him of which two died. When I was 24 I ran away from him and this time my father agreed with me. The headmaster at the school was kind enough to take me back so that I could complete middle school, and then I went on to teacher training college. I taught for some time before joining the social welfare department. When I was teaching I became pregnant by the man who is now my husband. Then after that birth I became pregant again too soon and had to get rid of it. Also I wanted to go for an additional specialist course at the school of social welfare. Now I use the natural (rhythm) method of family planning. I am thinking of having one more child. I haven't discussed it with my husband. He has plenty of children with the other wives so he doesn't care whether I have any more or not.

6.1 Young Dagomba women in Accra

These are all controllers of fertility or at least potentially so. Three of them, Ayesha, Fate and Saratu, constitute a group of women in similar situations. They are of mixed northern descent. Their mothers are Dagomba and their fathers of non-Ghanaian extraction. There is therefore mobility in their backgrounds. They themselves are also married to non-Dagomba. Like their husbands they have a little education and a lot of experience in trade. Within their community they are fairly wealthy people. Ayesha, Fate and Saratu have wealth in inverse proportion to their education. This reflects the current economic situation. As Fate, the most educated, said: "I chose to become a civil servant and if I am poor I know why". She too is dropping out of white-collar work and moving into trade. For these three their mobility is a factor in motivating them to control fertility. Kin are not immediately on hand to help with child-care and fostering children out would mean sending them a long way away, so that it would be impossible for them to see their children often. Relative wealth is also a factor. They might not be satisfied with the standard of living that would be offered to their children in the homes of kin or affines. Involvement in their occupational role is also relevant. They would not want to have a lot of children and keep them in the home because it would restrict their trading activities for some years.

For Nafisa, mobility and the husband's education and ambitions are factors in restricting her fertility. If she were in Tamale with wealthy kin to help her with child-care she would be less tied to the home by children than she is in Accra. Also the husband has a higher education and aspires to a senior position in government employment. He wants the best education for his children and is struggling financially. His wishes influence Nafisa a lot. If her father had married her to a wealthy illiterate in Tamale she might be contemplating having many more children.

Wilhemina has been raised in a privileged city home in an environment of both wealth and education. Large families would not be common amongst her acquaintances and role models.

None of these young women has a high level of education. The two who have gone beyond elementary education have secretarial and catering training.

6.2 Role differences and birth control

What is of particular interest in our analysis is that significant differences are observable between women who systematically have used contraception and the rest in terms of several related role behaviours and expectations.

(i) Maternal/occupational role conflict

The role expectations and activities most in conflict with maternal responsibilities are those associated with an occupation. However, there is some variation in the amount of such conflict experienced by women, depending upon the degree of separation of work and home and the availability of kin and others to whom child-care and domestic tasks can be satisfactorily delegated. Thus, as has been frequently hypothesised, women whose work is located at a distance from the home and who work longer hours and thus feel more pressured and experience more time strain and conflict between occupational and domestic activities and responsibilities are those most likely to be systematic contraceptive users.[3] It is not employment per se or income earning which appears to be related to birth control, but the type of work and how it affects resources in time available for other activities in the home. Thus while only one woman out of 11 paid family workers or self-employed is a systematic user of contraception, 16 women out of 41 employed in large private firms or government service are systematic users.

(ii) Maternal role: child-care

There are also statistically significant differences in the child-care activities, resources and expectations between women who more systematically use contraception and the rest. Of women who are highly conscious of maternal care, 41 per cent are systematic users, of those partially conscious 31 per cent and only 25 per cent among those who do not appear consciously to think about child-rearing. Those who practice contraception also desire and practice more personal supervision of their children, and they approve less of child-care delegation. They have less assistance from relatives and others and have been separate from their children less often. Accordingly they feel somewhat more under strain and experience lack of time for child-care. They also desire smaller family sizes.

It is interesting to compare these findings with those of R.A. Leve (1984), where the hypothesis after comparing infant care among the Gusii of Kenya, a Mayan community in Yucatan and the United States, was that Gusii mothers would not begin to deliberately limit births "until they acquire new concepts of what is involved in raising children in terms of both ends and means. This might occur through urbanisation on a larger scale than Kenya has seen to date through intensive efforts to implement Family Planning, through continued increases in the education of women or through some combination of these and other changes" (p. 8).

Women who more systematically control conception also differ from other women with regard to their conjugal relationships, a phenomenon which has been documented in a wide range of studies in different cultures. They enjoy more harmony between their

maternal and conjugal roles. They have husbands with higher levels of professional status and also a tendency to stress more the companionate aspect of their relaticnship (cf. Richard and El Awad Galal el Din, 1982, pp. 35-36). They also live in better accommodation, with fewer co-resident relatives and enjoy a higher level of social status from their domestic situation. At the same time as individuals they enjoy more friendship and leisure pursuits.

7. Conclusions

In this discussion regarding the timing, spacing and numbers of births, evidence has been presented which supports a number of hypotheses linking later marriage, more costly child-care and greater occupational/maternal role conflicts with lowering of family size and more careful control of births. The ways in which children may become more costly of parental time have been indicated, as well as the particular aspects of the occupation which are likely to be linked to greater strain and conflict and thus the propensity to use contraception. In the last chapter some of the research and policy implications of this micro study are discussed.

Notes

[1] This refers to middle and older age groups because some in the younger age group were not yet mothers.

[2] Wealth in this case has not been assessed according to any single index but through a combination of several types of evidence. These include the economic rewards of their own formal and informal sector work and those of their husbands where relevant. The precise measurement of informal sector incomes is notoriously difficult, but in the present contexts, some lines of trade are known to be much more profitable than others. Butchers are always quite well off, fishermen much less so, although women fish wholesalers can be very wealthy. The ownership by themselves or husband of capital equipment such as commercial or agricultural vehicles, grinding mills or workshop equipment was also considered relevant, as was ownership or likely inheritance of houses.

[3] Systematic contraceptive usage is significantly correlated with location of work away from home, number of hours worked, level of time strain perceived through work and amount of conflict experienced between occupational and domestic roles. The tests of association used here and elsewhere were X^2, Kendall's Tau and Pearson's R.

CHAPTER VI

CONCLUSIONS

Various approaches to the study of differential fertility and factors affecting motivation, innovation and the capacity to plan family size have been identified in the research literature of several disciplines.[1]

A major problem identified in many studies has been that of specifying the intervening linkages at the household level through which macro socio-economic factors have an impact upon fertility. There has been increasing recognition that many of these intervening factors are to be found in the area of changes in the relative equality of the family members by sex and generation with respect to allocation of resources and responsibilities both within and outside the home (Oppong, 1984). In addition the extent to which the conjugal family is a closed unit has been demonstrated to be critical (Oppong, forthcoming). Both of these sets of variations have important impacts upon the levels and modes of allocating child costs (Oppong, 1982a, 1983a).

In this study some of the impacts of the introduction of education and modern formal sector employment opportunities and the associated migration upon familial roles and relationships have been examined. These include the availability and use of domestic time, the perceived costs of child-care and how these are spread and the attempts of mothers to use more of their own time for mothering. During the analysis a variety of differences and changes in women's roles have been discussed in terms of data gathered using a conceptual framework of women's roles, which incorporates activities, role expectations, resources and relationships. The rewards or statuses associated with the various roles were considered, as were the potential conflicts between the occupational and maternal roles and also between the latter and all other roles. The analysis has involved a more sophisticated approach to women's "status" than is conventional, viewing the various rewards and benefits accruing from each of the seven roles in forms which can be indexed and compared. It has also included a careful estimation of the time and material inputs to child-care and their relative cost in terms of time, materials and opportunities forgone and at the same time an examination of the contexts, conditions and outcomes of role conflict or incompatibility of various kinds.

The data were collected by means of focused biographies from 60 women in two cities, Accra and Tamale, subject in varying degrees to "modernising" factors of urban employment, migration, penetration of a market economy and education. Two ethnic groups were included, the Dagomba of the north and the Ga of the Accra region.

The data collected were used to examine a number of hypotheses regarding the impacts of education, urban employment and migration upon women's roles, especially the maternal role. The findings support the contention that, in order to understand reproductive behaviour and expectations, it is necessary to understand the changes in family relations associated with the social and spatial mobility involved in education, training and new job opportunities. On the theoretical level the study is thus one more demonstration of the need to put the family system, and how it is changing in different contexts, firmly in the centre of models attempting to explain differential and changing fertility.

As regards methodology the value was once more demonstrated of a micro data set, this time involving the collection of 60 focused biographical accounts.

On the level of practical policy formulation, attention is drawn to the importance of enlightening women, especially in West Africa, about the potential consequences of repeated and illegal abortions. Some use this as a regular method of birth control and child spacing, unfortunately assuming that it has fewer side-effects and will have less deleterious impacts upon their future reproductive capacity than contraceptive methods they can obtain. Information obviously needs to be made more readily available to disabuse women of such ideas. In addition, services and a wider range of contraceptive methods need to be made available. In particular, access is required to methods which do not continuously interfere with normal physiological functions, with no side-effects, and which do not require continuous medical supervision.

With regard to processes of change, the findings support the argument that if in the Ghanaian situation education and salaried employment are not accompanied by changes in family relationships - including a perceived need for more personal parental care, leading to a greater investment of individual parents' time and thus to some role strain and perceived lack of resources - there will not necessarily be any link connecting them with lower family size preferences or systematic birth control. In other words, if West African parents continue as in the past to feel able to spread the time and money requirements of child-rearing among kin and other helpers, constraints to high fertility which operate in other cultural contexts will not be felt.

Subtle and profound changes in family relationships are seen once again as essential intervening linkages between the macro changes in educational and employment institutions on the one hand, and goals and patterns of child-bearing, rearing and family planning and thus ultimately family size and fertility on the other (Oppong, 1985a).

The method of data collection and analysis demonstrated in this work thus provides a cross-culturally applicable means for examination of women's changing roles and statuses in the household, community and labour force and how they relate to micro and macro processes of economic and demographic change in diverse national contexts. Improved understanding of such

dynamics at the individual, local and national level is needed as a practical basis for planning future population programmes and the design of sound development policies.

Note

[1] For example, see "Research on the determinants of fertility: A note on priorities", in Population and Development Review (New York, Population Council), Vol. 7, No. 2, June 1981.

BIBLIOGRAPHY

Abate, Y. 1980. "Demographic factors in Africa's development", in Rural Africana (East Lansing, Michigan, Michigan State University), spring, Vol. 7, pp. 15-36.

Abu, K. 1983. "The separateness of spouses: Conjugal resources in an Ashanti town", in Oppong (ed.), 1983, op. cit.

Akuffo, F.O. 1982. High wastage in women's education: The case of the rural elementary schoolgirls. Accra, NCWD; mimeographed. Conference Proceedings.

---. Forthcoming. "Teenage pregnancies and school drop-outs", in Oppong (ed.), forthcoming, op. cit.

Ameyaw, S. 1977. Participation of women in policy-making positions in the local, national and international levels. Accra, NCWD; mimeographed.

Ampofo, D.A. n.d. Abortion and contraception, PPAG Tenth Anniversary Report, pp. 23-24. n.p.

---. 1971. "Abortion in Accra: The social, demographic and medical perspectives", in N.O. Addo et al. (eds.): Symposium on implications of population trends for policy measures in West Africa. Legon, University of Ghana.

Anker, R. 1983a. Female labour force activity in developing countries: A critique of current data collection techniques. Geneva, ILO; mimeographed World Employment research working paper; restricted.

---. 1983b. Effect on reported levels of female labour force participation in developing countries of questionnaire design, sex of interviewer and sex/proxy status of respondent: Description of a methodological field experiment. Geneva, ILO; mimeographed World Employment Programme research working paper; restricted.

Anker, R.; Buvinic, M.; Youssef, N. (eds.). 1982. Women's roles and population trends in the Third World. London, Croom Helm.

Ardayfio, E. 1986. The rural energy crisis in Ghana: Its implications on women's work and household survival. Geneva, ILO; mimeographed World Employment Programme research working paper; restricted.

Arhin, K. 1983. "The political and military roles of Akan women", in Oppong (ed.), 1983, op. cit.

Aryee, A.; Gaisie, S. 1979. Fertility implications of contemporary patterns of nuptiality in Ghana, paper presented at an IUSSP seminar on Nuptiality and Fertility, Bruges, January.

Azu, D.G. 1974. The Ga family and social change. Leiden, African Social Research Documents.

Bequele, A. 1983. "Stagnation and inequality in Ghana", in D. Ghai and S. Radwan (eds.): Agrarian policies and rural poverty in Africa. Geneva, ILO.

Bertaux, D. (ed.). 1981. Biography and society: The life history approach in the social sciences. London, Sage Publications.

Biddle, B.J. 1979. Role theory: Expectations, identities and behaviour. London, Academic Press.

Bleek, W. 1976a. Sexual relationships and birth control in Ghana: A case study of a rural town. Amsterdam, University of Amsterdam.

---. 1976b. "Spacing of children, sexual abstinence and breast-feeding in rural Ghana", in Social Science and Medicine (New York, Pergamon Press), Vol. 10, pp. 225-230.

---. 1978. "Induced abortion in a Ghanaian family", in African Studies Review (Los Angeles, African Studies Association), Apr., Vol. XXI, No. 1.

---. 1981. "The unexpected repression: How family planning discriminates against women in Ghana", in Review of Ethnology (Vienna), Vol. 7, No. 25.

---. Forthcoming. "Family planning and the family in Southern Ghana", in Oppong (ed.), forthcoming, op. cit.

Boserup, E.. 1985. "Economic and demographic interrelationships in Sub-Saharan Africa", in Population and Development Review (New York, Population Council), Vol. 11, No. 3, pp. 383-393.

Bulatao, R.A. et al. (eds.). 1983. Determinants of fertility in developing countries. Vol. 1: Supply and demand for children; Vol. 2: Fertility regulation and institutional influences. London, Academic Press.

Cain, M. 1984. Women's status and fertility in developing countries, Working Paper No. 110. New York, Population Council.

Caldwell, J.C. 1968. Population and family change in Africa: The new urban elite in Ghana. Canberra, Australian National University Press.

---. 1969. African rural-urban migration: The movement to Ghana's towns. Canberra, Australian National University Press.

---. 1982. Theory of fertility decline. London, Academic Press.

Campbell-Platt, K. 1978. Women in senior posts in the civil service. Accra, NCWD; mimeographed.

---. 1982. Drop out rates among girls and boys in the primary, middle and secondary levels of education in selected schools in Accra. Accra, NCWD; mimeographed. Conference Proceedings.

Church, K.V. 1978. Women and family life in an Ashanti town, Thesis presented in part fulfilment of the requirements for the degree of M.A. in African studies. Legon, University of Ghana.

---. 1982. A study of socio-economic status and child care arrangements of women in Madina. Accra, NCWD; mimeographed. Conference Proceedings.

Cicourel, A.A. 1975. Theory and method in a study of Argentina fertility. New York and London, J. Wiley and Sons.

Cochrane, S.H. 1979. Fertility and education. What do we really know?, World Bank Staff Occasional Papers No. 26. Baltimore, Johns Hopkins University Press.

---. 1983. "Effects of education and urbanisation on fertility", in Bulatao et al. (eds.), op. cit., Vol. 2.

Date-Bah, E. 1982. Sex segregation and sex discrimination against women in the formal sector of the urban labour market of Accra-Tema. Geneva, ILO; mimeographed World Employment Programme research working paper; restricted.

de Graft-Johnson, K.T. 1974. "Population growth and rural-urban migration with special reference to Ghana", in International Labour Review (Geneva, ILO), Vol. 109, No. 5-6, pp. 471-485.

Dinan, C. 1983. "Gold diggers and sugar daddies", in Oppong (ed.), 1983, op. cit.

Economist Intelligence Unit. 1980-81. Quarterly economic reviews of Ghana, Sierra Leone, The Gambia, Liberia. London.

Elder, G. 1974. Children of the Great Depression. Chicago, University of Chicago Press.

---. 1981. "History and the life course", in Bertaux (ed.), op. cit.

Epstein, T.S. 1982. A social anthropological approach to women's roles and status in developing countries: The domestic cycle, in Anker, Buvinic and Youssef (eds.), op. cit.

Erny, P. 1981. The child and his environment in Black Africa, an essay on traditional education translated, abridged and adapted by G.J. Wanjohi. Nairobi, Oxford University Press.

Ewusi, K. 1982. Occupations of women in Ghana. Accra, NCWD; mimeographed. Conference Proceedings.

Field, M.J. 1940. Social organization of the Ga people. Accra, Crown Agents for the Colonies.

Findley, S.E. 1982. International Encyclopedia of Population, Vol. 1, pp. 247-252. New York, Free Press.

Fitzgerald, D.K. 1968. The question of duo-locality among the Ga: A preliminary study. Legon, Institute of African Studies; mimeographed.

Fortes, M. 1949. The web of kinship among Tallensi. Oxford, Oxford University Press.

---. 1950. "Kinship and marriage among the Ashanti", in A. Radcliffe-Brown and D. Forde (eds.): African systems of kinship and marriage. London, Oxford University Press.

---. 1954. "A demographic field study in Ashanti", in F. Lorimer (ed.): Culture and human fertility, pp. 253-95. Paris, UNESCO.

---. 1974. "The first born", in Journal of Child Psychology and Psychiatry (Elmsford, New York, Pergamon Press), Vol. 15, pp. 81-104.

---. 1978. "Family, marriage and fertility in West Africa", in Oppong et al. (eds.), 1978, op. cit.

François, E.M. 1981. Workload of Ghanaian women: Home managers - An exploratory study in Accra, Ph.D. thesis, University of Guelph.

Gaisie, S.K. 1976. Estimating Ghanaian fertility, mortality and age structure, University of Ghana Population Studies No. 5. Legon.

---. 1979. "Mortality, socioeconomic differentials and modernization in Africa", in United Nations, Economic Commission for Africa: Population dynamics, fertility and mortality in Africa, pp. 461-463. Monrovia, Addis Ababa.

---. 1981. "Child spacing patterns and fertility differentials in Ghana", in Page and Lesthaeghe (eds.), op. cit.

Gaisie, S.K.; Nabila, J. 1978. Determinants of fertility patterns and their implications for the Ghana population policy, IUSSP Case Studies on Population Policies in Developing Countries; mimeographed.

Goody, E.N. 1973. Contexts of kinship. Cambridge, Cambridge University Press.

---. 1982. Parenthood and social reproduction: Fostering and occupational roles in West Africa. Cambridge, Cambridge University Press.

Hill, R.; Stycos, M.; Back, K. 1959. The family and population control. Chapel Hill, University of North Carolina Press.

ILO. 1974. Year Book of Labour Statistics. Geneva.

Kasarda, J.D. 1971. "Economic structure and fertility: A comparative analysis", in Demography (Washington, DC, Population Association of America), Vol. 8, No. 3, Aug., pp. 52-63.

Kilson, M. 1966. African urban kinsmen: The Ga of Central Accra. London, Hunt and Co.

Kirk, D. 1966. "Factors affecting Moslem natality", in Family planning and population programs: A review of world development, pp. 561-579. Chicago, University of Chicago Press.

Kohl, M. 1981. "Biography: Account, text, method", in Bertaux (ed.), op. cit.

Kupinsky, S. (ed.). 1977. The fertility of working women: A synthesis of international research. New York, Praeger.

Levine, R.A. 1978. "Comparative notes on the life course", in T.K. Hareven (ed.): Transitions: The family and the life course in historical perspective. London, Academic Press.

---. 1980. "Influences of women's schooling on maternal behaviour in the Third World", in Comparative Education Review (Los Angeles), June, Vol. 24, No. 2, pp. 78-105.

---. 1984. Maternal behaviour and child development in high fertility populations, Fertility Determinants Research Notes No. 2. New York, Population Council.

Levine, S. 1979. Mothers and wives: Gusii women of East Africa. Chicago and London, University of Chicago Press.

MacIntyre, W.G.; Nass, G.D.; Dreyer, A.S. 1974. "Parental role perceptions of Ghanaian and American adolescents", in Journal of Marriage and the Family (Minneapolis, National Council on Family Relations), Vol. 36, No. 1.

Mueller, E. 1982. "The allocation of women's time and its relationship to fertility", in Anker, Buvinic and Youssef (eds.), op. cit.

National Council on Women and Development (NCWD), Ghana. 1982. Proceedings of the Seminar on Ghanaian Women in Development, Sep. 1978, Vols. 1 and 11. Accra; mimeographed.

Nukunya, G. 1969. Kinship and marriage among the Anlo Ewe. London, Athlone Press.

Okali, C. 1983. Cocoa and kinship in Ghana. London, Kegan Paul International.

---. 1983. "Kinship and cocoa farming in Ghana", in Oppong (ed.), 1983, op. cit.

Oppenheim Mason, K. 1984. The status of women: A review of its relationship to fertility and mortality. New York, Rockefeller Foundation.

Oppong, C. 1970. "Conjugal power and resources: An urban African example", in Journal of Marriage and the Family, Vol. 32, No. 4, pp. 676-680.

---. 1973. Growing up in Dagbon. Ghana, Ghana Publishing Corporation.

---. (ed.). 1974 and 1975. Legon Family Research Papers, Vols. 1 and 3. Legon, Institute of African Studies.

---. 1975. "Norms and variations: A study of Ghanaian students' attitudes to marriage and family living", in C. Oppong (ed.): Changing Family Studies, Legon Family Research Papers No. 3. Legon, Institute of African Studies.

---. 1977a. "The crumblings of high fertility supports", in J.A. Caldwell (ed.): The persistence of high fertility: Population prospects in the Third World. Canberra, Australian National University.

---. 1977b. "Issues concerning the changing status of African women: Some lessons from the Ghanaian experience", in International Planned Parenthood Federation: Family welfare and development in Africa. London.

---. 1980. A synopsis of seven roles and status of women: An outline of a conceptual and methodological approach. Geneva, ILO; mimeographed World Employment Programme research working paper; restricted.

---. 1982a. "Family structure and women's reproductive and productive roles", in Anker, Buvinic and Youssef (eds.), op. cit.

---. 1982b. Middle class African marriage. London, George Allen and Unwin; reprint of 1974.

---. 1983a. "Women's roles, opportunity costs and fertility", in Bulatao et al. (eds.), op. cit.

---. 1983b. Paternal costs, role strain and fertility regulation: Some Ghanaian evidence. Geneva, ILO; mimeographed World Employment Programme research working paper; restricted.

--- (ed.). 1983. Female and male in West Africa. London, George Allen and Unwin.

---. 1984. "Familial roles and fertility: Some labour policy aspects", in United Nations Population Division: Family and fertility, Volume for World Population Conference. New York.

---. 1985a. "Aspects of anthropological approaches", in G. Farooq and G. Simmons (eds.): Fertility in developing countries: An economic perspective on research and policy issues. London, Macmillan.

---. 1985b. "Marriage", in A. and J. Kuper (eds.): A new social science encyclopedia. London, Routledge.

---. Forthcoming. "Responsible fatherhood and birth planning", in Oppong (ed.), forthcoming, op. cit.

Oppong, C. et al. 1977. Population and development policy research project: Women's roles and fertility in West Africa: A biographical approach. Legon, submitted to the Rockefeller Foundation.

Oppong, C. et al. (eds.). 1978. Marriage, fertility and parenthood in West Africa. Canberra, Australian National University.

Oppong, C.; Abu, K. 1985. A handbook for data collection and analysis of seven roles and statuses of women. Geneva, ILO.

Oppong, C.; Bleek, W. 1982. "Economic models and having children: Some evidence from Kwahu, Ghana", in Africa (London), Vol. 52, No. 4, pp. 15-32.

Oppong, C.; Church, K.V. 1981. A field guide to research on seven roles of women: Focused biographies. Geneva, ILO; mimeographed World Employment Programme research working paper; restricted.

Oppong, C.; Haavio-Mannila, E. 1979. "Women, population and development", in P.M. Hauser (ed.): World population and development: Challenges and prospects. Syracuse, New York, Syracuse University Press.

Oppong, C.; Okali, C.; Houghton, B. 1975. "Women power. Retrograde steps in Ghana", in African Studies Review, Vol. XV, pp. 71-84.

--- (ed.). Forthcoming. Sex roles, population and development in West Africa.

Page, H.J.; Lesthaeghe, R. (eds.). 1981. Child-spacing in tropical Africa: Tradition and change. London and New York, Academic Press.

Pappoe, M. 1982. Women and abortion, Proceedings of the Seminar on Ghanaian Women in Development. Accra, NCWD; mimeographed.

Parry, G.; Warr, P. 1980. "The measurement of mothers' work attitudes", in Journal of Occupational Psychology (Leicester, British Psychological Society), Vol. 53, pp. 245-262.

Pittin, R. 1982. Documentation of women's work in Nigeria: Problems and solutions. Geneva, ILO; mimeographed World Employment Programme research working paper; restricted.

---. Forthcoming. "Documentation of women's work in Nigeria: Problems and solutions", in Oppong (ed.), forthcoming, op. cit.

Population Council. 1981. "Research on the determinants of fertility. A note on priorities", in Population and Development Review, Vol. 7, No. 2.

Richard, J.; El Awad Galal el Din, M. 1982. "The beginnings of family limitations", in Demographic transition in metropolitan Sudan, Changing African Family Project series, Monograph No. 9.

Robertson, C. 1974. "Economic women in Africa: Profit-making techniques of Accra market women", in Journal of Modern African Studies (Cambridge, Cambridge University Press), No. 12, pp. 657-664.

---. 1977. "The nature and effects of differential access to education in Ga society", in Africa, No. 2, pp. 208-219.

Rosen, B.C. 1973. "Social change, migration and family interaction in Brazil", in American Sociological Review (Washington, DC, American Sociological Association), Apr., Vol. 38, pp. 198-212.

Rosen, B.C.; Simmons, A.B. 1971. "Industrialization, family and fertility: A structural psychological analysis of the Brazilian case", in Demography, No. 8, pp. 49-69.

Ryder, N.B. 1978. "Some problems of fertility research", in K.E. Taeuber, L.L. Bumpass and J.A. Sweet (eds.): Social demography. London, Academic Press.

Safilios-Rothschild, C. 1979. "Sociopsychological factors affecting fertility in urban Greece: A preliminary report", in Journal of Marriage and the Family, Aug., Vol. XXXI, No. 3, pp. 595-606.

Schildkrout, E. 1973. "The fostering of children in urban Ghana: Problems of ethnographic analysis in a multicultural context", in Urban Anthropology (New York), No. 1.

Shostak, M. 1983. Nisa: The life and words of a !Kung woman. New York, Vintage Books.

Smith, M. 1954. Baba of Karo: A woman of the Muslim Hausa. London, Faber and Faber Publications.

Standing, G. 1978. Labour force participation and development. Geneva, ILO.

---. 1983. "Fertility and women's work activity", in Bulatao et al. (eds.), op. cit.

Steel, W.F. 1981. "Female and small-scale employment under modernization in Ghana", in Economic development and cultural change (Chicago, University of Chicago Press), Vol. 3, No. 1, pp. 153-167.

Stone, L. 1977. The family, sex and marriage in England: 1500-1800. New York, Harper and Row.

Thompson, P. 1981. "Life histories and the analysis of social change", in Bertaux (ed.), op. cit.

Tietze, C. 1981 and 1983. Induced abortion: A world review. A Population Council Fact Book, 4th edition. New York, Population Council.

United Nations. 1982. Evaluation of the impact of family planning programmes on fertility: Sources of variance, Population Studies No. 76. New York, Department of International Economic and Social Affairs.

---. 1983. Relationships between fertility and education: A comparative analysis of World Fertility Survey data for twenty-two developing countries. New York; doc. ST/ESA/SER.R/48.

United States Bureau of Census. 1977. Country demographic profiles, Ghana. Washington, DC.

United States Department of Labor. 1980. Country labor profile, Ghana. Washington, DC, Bureau of International Labor Affairs.

Vellenga, D.D. 1977. "Attempts to change the marriage laws in Ghana and the Ivory Coast", in P. Foster and A. Zolberg (eds.): Ghana and the Ivory Coast: Perspectives on modernization. Chicago, Chicago University Press.

---. 1983. "Who is a wife?", in Oppong (ed.), 1983, op. cit.

Ware, H. 1975. The relevance of changes in women's roles to fertility behaviour: The African endeavour, Paper presented at the Population Association of America Meeting. Mimeographed.

---. 1977. "Women's work and fertility in Africa", in Kupinsky (ed.), op. cit.

---. 1983. "Female and male life-cycles", in Oppong (ed.), 1983, op. cit.

Weis, L. 1983. "Inequality in Ghanaian secondary schools: Educational expansion, recruitment and internal stratification", in International Review of Education (The Hague), Vol. XXIX, pp. 21-36.

World Fertility Survey (WFS). 1983. The Ghana Fertility Survey, 1979-80: A summary of findings. London.

Youssef, N. 1982. "The inter-relationship between the division of labour in the household: Women's roles and their impact on fertility", in Anker, Buvinic and Youssef (eds.), op. cit.